Calatrava Bridges

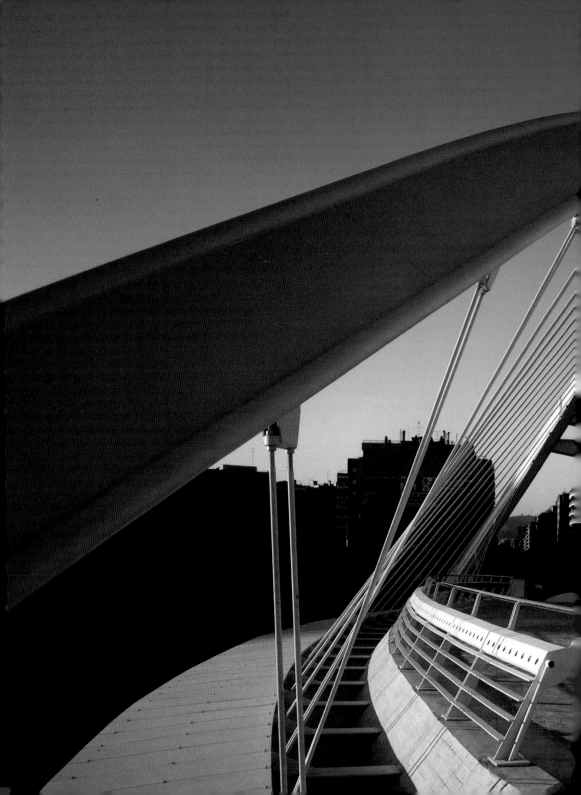

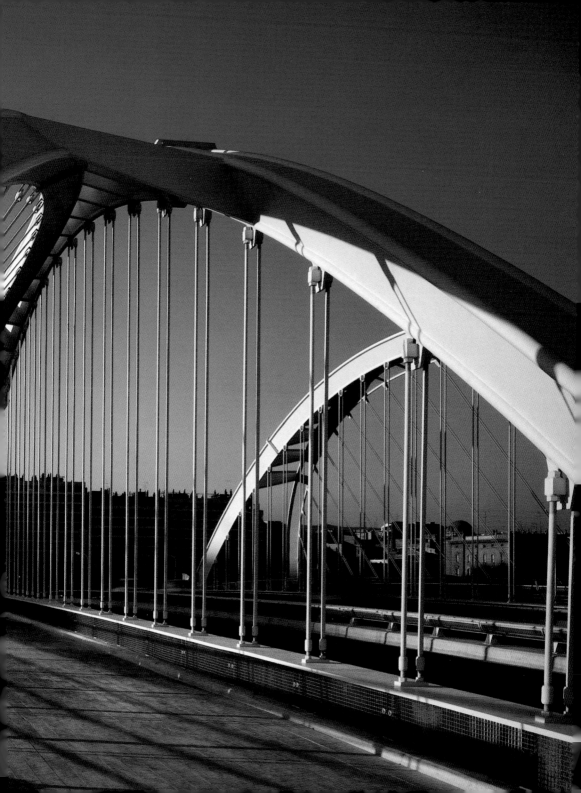

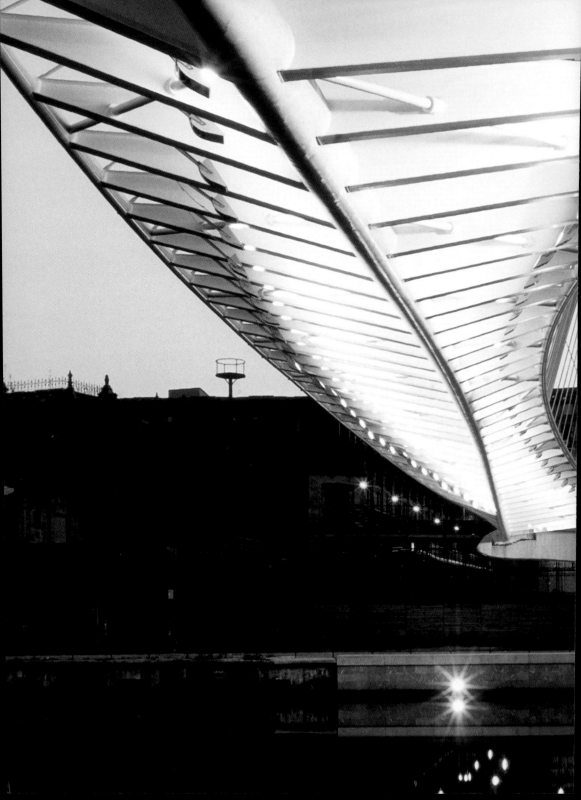

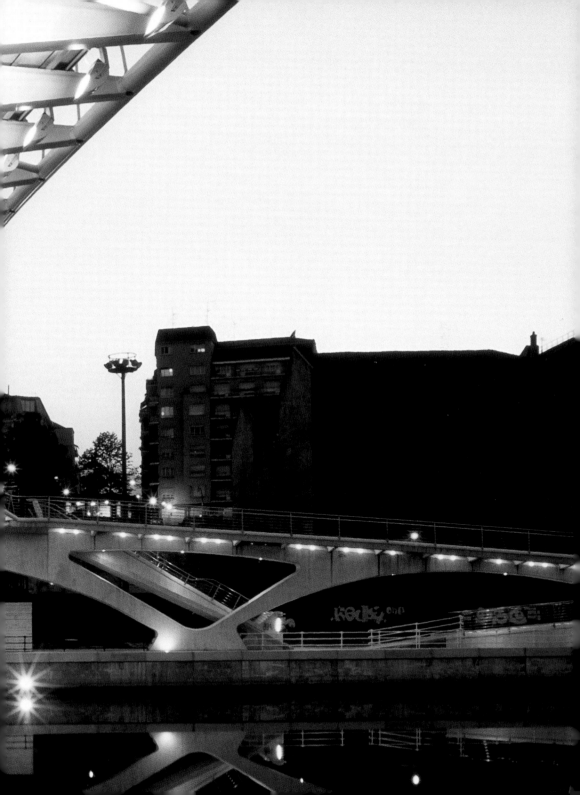

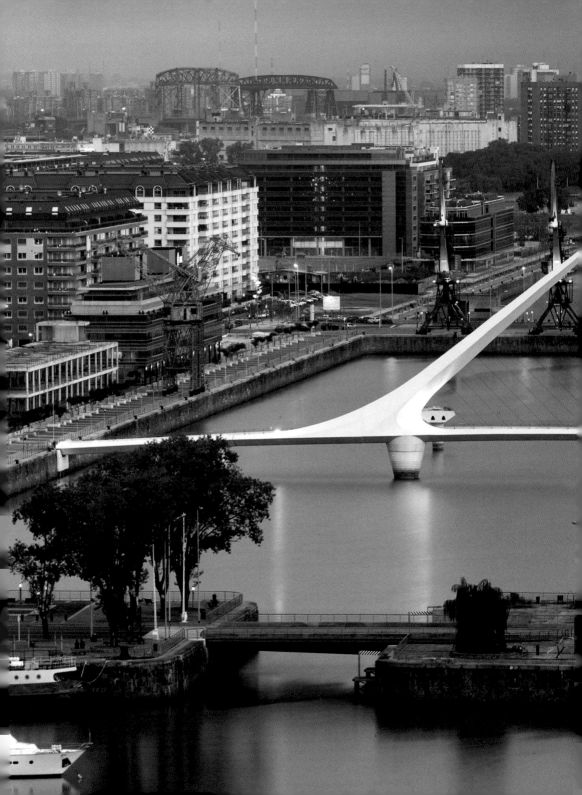

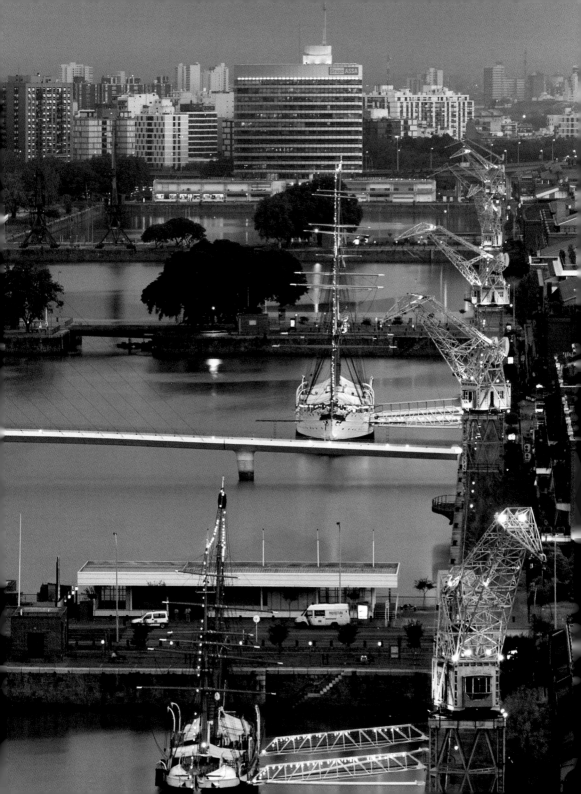

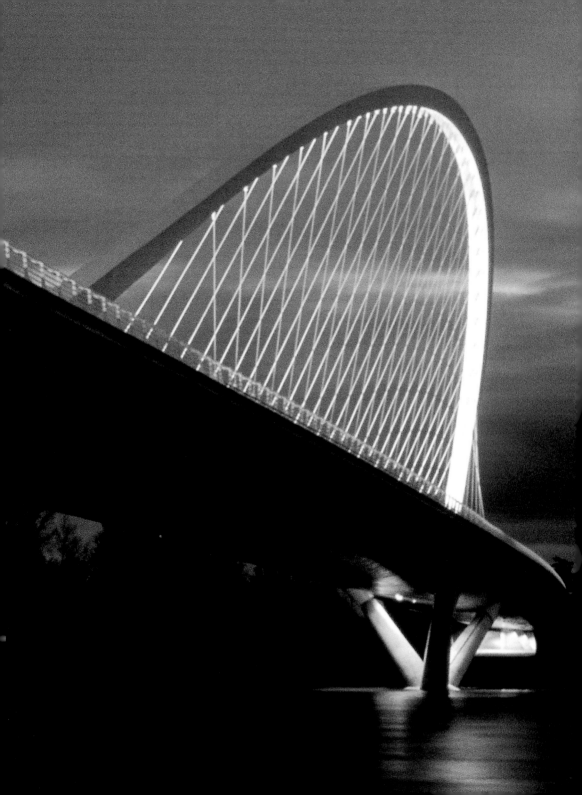

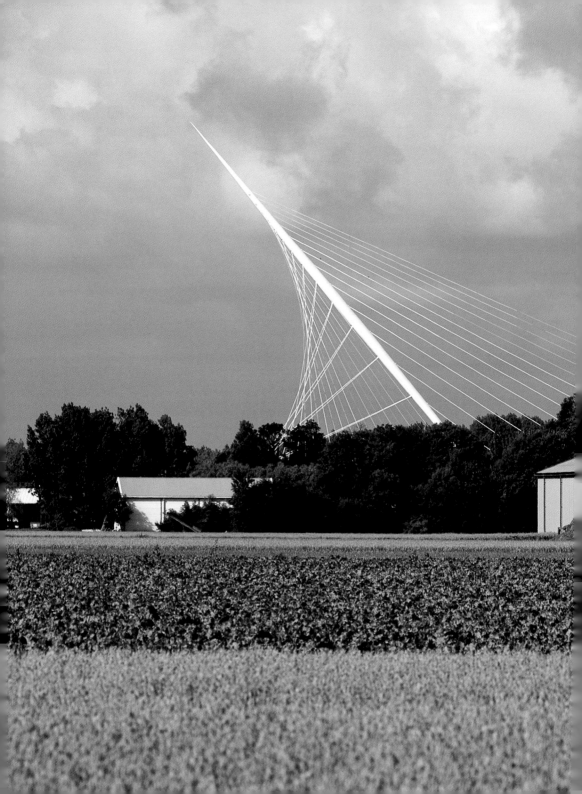

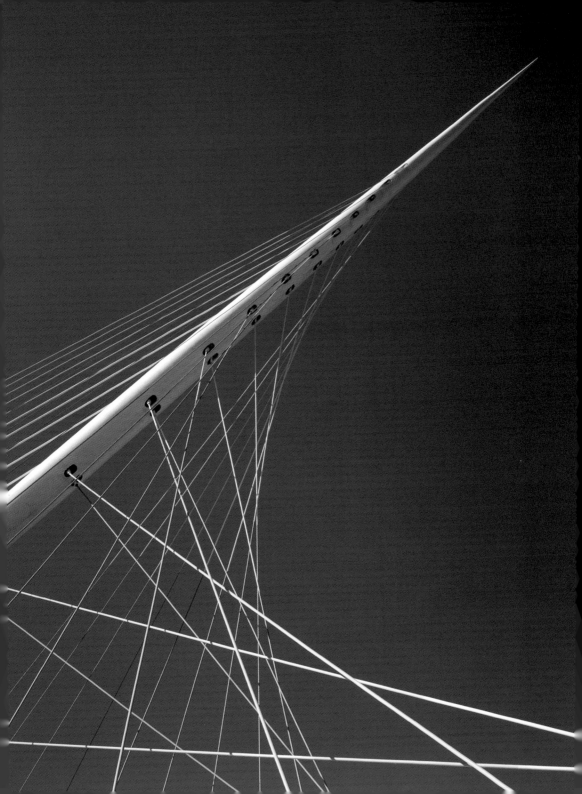

Calatrava Bridges

ALEXANDER TZONIS

REBECA CASO DONADEI

Thames & Hudson

Opposite: Detail of Katehaki Pedestrian Bridge, Athens, Greece.

Pages 2–3: Campo Volantin Footbridge, Bilbao, Spain.
Pages 4–5: Puente de la Mujer, Buenos Aires, Argentina. Pages 6–7: Bach
de Roda Bridge, Barcelona, Spain. Pages: 8–9: Bridge over the Hoofdvaart,
Hoofddorp, Netherlands. Pages 10–11: Pont de l'Europe/Pont d'Orléans.
Page 12: Detail of Bridge over the Hoofdvaart. Pages 28–29: Alpine bridge
proposal. Pages 54–55: Bach de Roda Bridge. Pages 124–25: Bridge over
the Hoofdvaart. Pages 176–77: Pont de l'Europe/Pont d'Orléans.
Pages 202–3: James Joyce Bridge, Dublin, Ireland. Pages 242–43: Alcoy
Community Hall, Alcoy, Spain.

Photography Credits: Barbara Burg and Oliver Schuh: 54–55, 131, 139, 140–41,
145, 191, 193, 207, 209, 213, 220, 221, 222–23, 224–25, 244, 251. Santiago Calatrava
Archive: 20, 56, 69, 75, 76–77, 156, 157, 210–11. Christophe Demonfaucon: 10–11,
25, 79, 159, 160–61, 176–77. Heinrich Helfenstein: 36–37, 42, 43, 45, 47, 52, 63, 65,
66–67, 72–73, 80, 82, 83, 84, 87, 91, 93, 94, 96, 97, 117, 120–21, 122, 136–37, 148, 149,
163, 164–65, 180–81, 183, 195, 199, 215, 216–17, 237, 240, 246. Timothy Hursley: 248,
263. Alan Karchmer: 4–5, 12, 15, 16, 26, 124–25, 126, 151, 152–53, 155, 167, 168–69,
171, 172–73, 174, 175, 227, 228–29, 231, 247, 258, 264, 266. Paolo Rosselli: 2–3, 22,
100–101, 104, 109, 132–33, 146–47, 178, 185, 188, 189, 204, 219, 242–43, 253, 255,
256–57. Hisao Suzuki: 6–7, 128–29. Tecnifoto: 99. Morley von Sternberg: 202–3,
233, 234–35.

First published in the United Kingdom in 2005 by
Thames & Hudson Ltd, 181A High Holborn,
London WC1V 7QX

www.thamesandhudson.com

British Library Cataloguing-in-Publication Data

A catalogue record for this book is available from the British Library

ISBN-13: 978-0-500-28579-4

ISBN-10: 0-500-28579-9

Design by Hahn Smith
Typeset in Helvetica Neu
Printed and bound in China

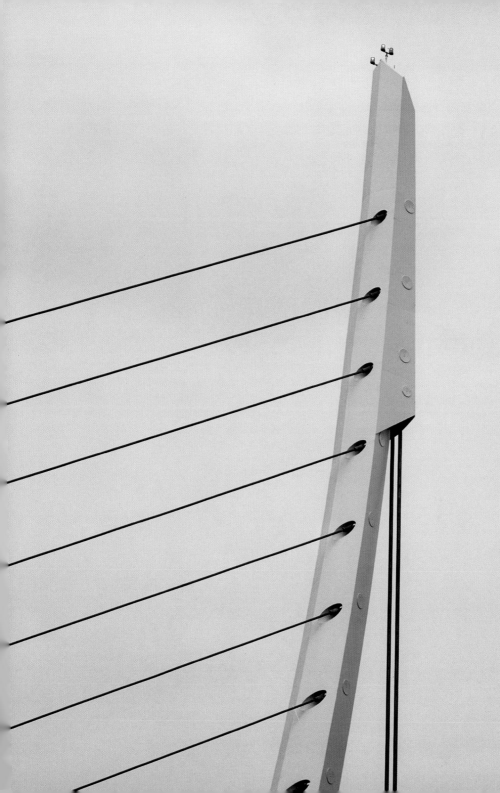

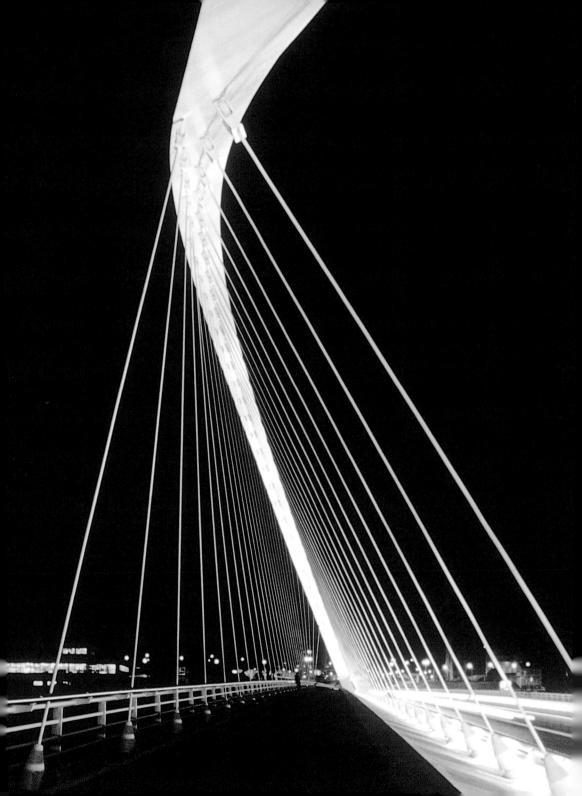

Contents

Opposite: Pont de l'Europe/Pont d'Orléans, Orléans, France.

Featured Project List

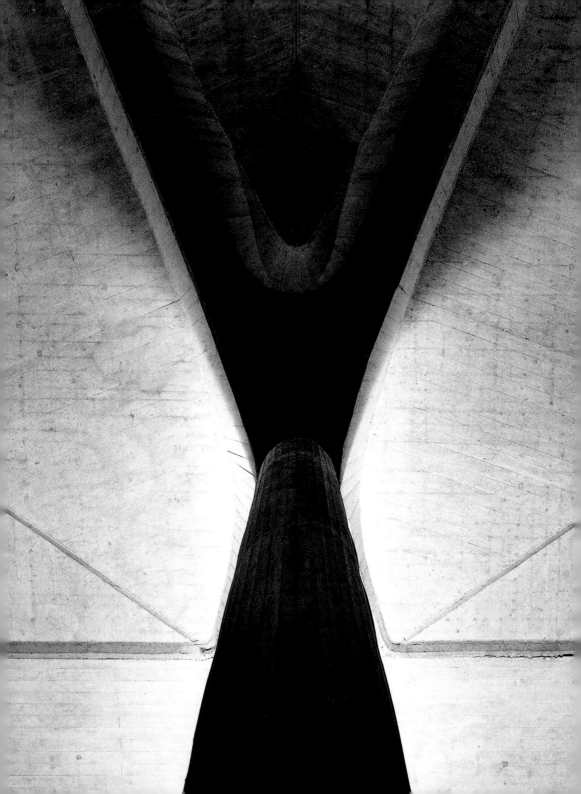

Acknowledgments

I am grateful to my publisher for giving me the opportunity to indulge once more in Santiago Calatrava's work, this time in his most fascinating, most challenging work to write about, bridges. I am also grateful to have had a collaborator, Rebeca Caso Donadei. Without her contribution this book would not have been possible. My thanks to Christof Mühlemann for preparing the visual documentation, to the staff of Santiago Calatrava, S.A., and to Kim Marangoni for helping in the research and supplying the project briefs used in this book. Many thanks to Ron Broadhurst, my editor at Universe, and to David Morton and Charles Miers for their effective support. Special thanks to all members of the Design Knowledge Systems Research Center of the Technical University of Delft and in particular my secretary, Janneke Arkesteijn. I would like to seize this opportunity and dedicate this book, unusual as it might be, to Santiago and Tina Calatrava for their collaboration, friendship, and inspiration.

A.T.

Opposite: Detail of 9 d'Octubre Bridge, Valencia, Spain.

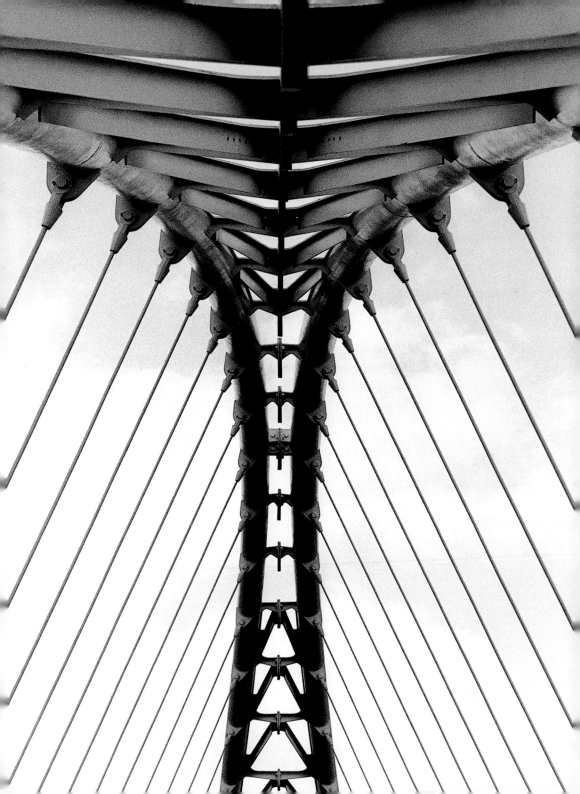

Introduction

Over a period of less than two decades, Santiago Calatrava revolutionized the idea of bridges in our time, reviving an excitement about them as objects not seen since the time of the Victorians. With this feat Calatrava has dispelled the bias that considers infrastructure works to be dull, utilitarian, and often disruptive, replacing it with a new enthusiasm for the art of construction. Calatrava has long maintained that bridges, as design objects, could combine technological intelligence with poetry to enhance the sense of identity and cultural significance of a particular place. He has demonstrated that they are collective symbols par excellence of the liberating power of creativity, hope, and community.

This achievement of Calatrava as a designer is very much the result of his uncommon attitude, and certainly his ability, to approach design challenges with a universal perspective. Indeed, there are very few designers of our time that have avoided the temptation to sacrifice the "old-fashioned" universal approach for the efficiency or effectiveness of reductive specialization, whether that specialization is technological or cultural. Calatrava was very aware that very often reductive specialization brought about in the end mixed results, leading to objects of sharply uneven quality: either functionally rich and culturally poor, or the reverse, functionally disadvantaged and culturally gorgeous. While Andrea Palladio in his *Four Books of Architecture* declared that bridges ought to be fitting, beautiful, and durable over a long period of time, the application of the scientific breakthroughs of Galileo and Robert Hooke to bridges targeted only a single aspect, stability. It was expected that this feature of bridge design would overshadow all others. The benefits of spanning large gaps to transport heavy objects were great; at the same time the costs of constructing bridges, as well as the risks in constructing them, were great. The new domain of scientific knowledge,

Opposite: Detail of Oudry-Mesly Footbridge, Créteil-Paris, France.

specifically regarding mechanics and strength of materials, could determine which kind of bridge scheme could support the maximum span and transport the maximum weight with the minimum of expense, and thereby supersede every other aspect of bridge design. As a result of this focus, bridges became one of the first building types to split away from the main body of architecture to employ a new conceptual system and a new methodology that could guarantee optimal functionality. Thus, the French Royal Academy of Architecture, the first institution to discuss and teach architecture, included in its program the design of bridges; yet, despite the fact that some of its members, like De La Hire and Courtonne, were distinguished scientists, the academy never became the center of development of this new discipline. This role was assumed by institutions that would always be disassociated from architecture and identified exclusively with the new branch of design that came to be known as engineering. Such places were the Ecole d'Artillerie, under the leadership of Bernard-Forest de Bellidor, the Ecole des Ponts et Chaussées, under Jean-Rodolphe Perronet, and more recently the Eidgenössische Technische Hochschule (ETH), or Swiss Institute of Technology, in Zurich, whose school of engineering Calatrava attended after obtaining a degree in architecture in Valencia.

Consequently, bridges could be seen as a simple kind of structure consisting of a deck and a support system. Although these few elements in combination can lead to many different schemes, in the end all possible permutations fall within a limited number of types: bridges that rest over an opening like a beam, an arch, or a frame, or that are cantilevered, or that are suspended over the opening. The objective of engineering appears to be simply to generate a scheme for such a structure that is optimal.

On the other hand, the price for this optimality was the elimination of numerous aspects that are part of a bridge proper. A bridge is not only a structure. In addition to requirements of stability, carrying its own weight and the weight of the objects transported across it, and resisting wind, rain, and seismic forces, it is also a conduit for the people and vehicles that move over it and the vessels passing under it. In addition to its basic structure, it must have connections with other paths on the ground, stairs, parapets, resting points, and lighting, to name only a few other features. Given the number and heterogeneity of all these necessities, therefore, the optimal solution to the problem of a bridge involves a synthesis of many "suboptimal" solutions satisfying many interests, desires, and points of view. In addition to being a

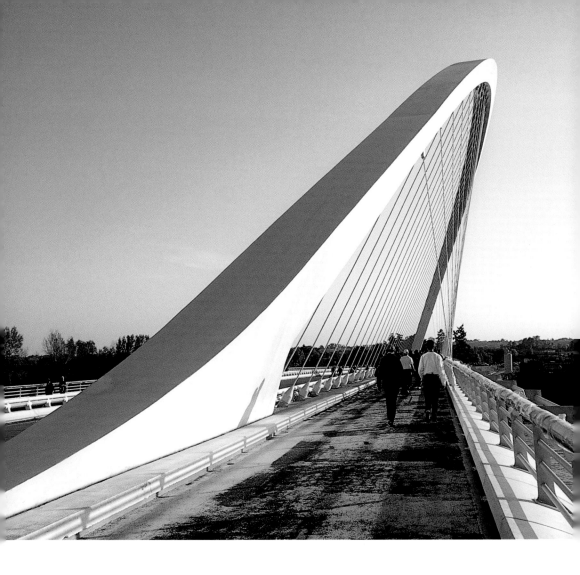

Pont de l'Europe/Pont d'Orléans, Orléans, France.

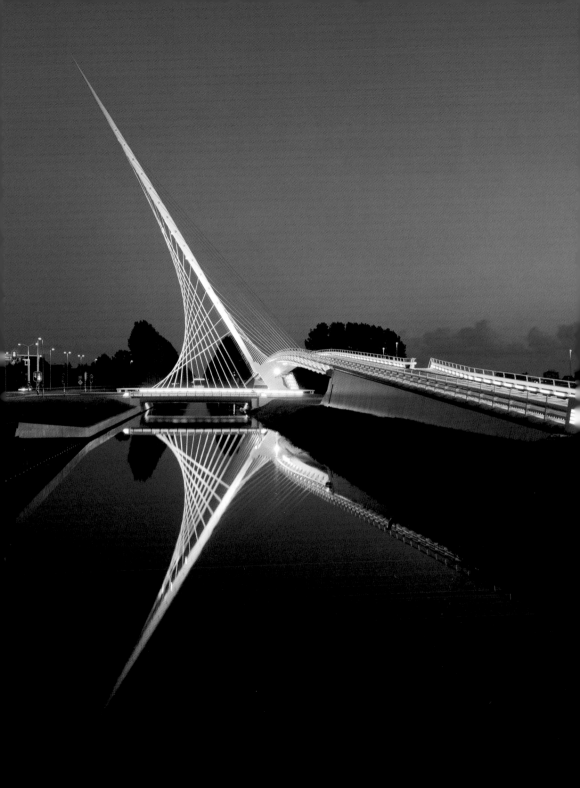

structure and a conduit that connects two or more locations to provide passage over a natural or artificial gap, a bridge is a physical object that has a presence in the human-made environment. This multivalent status poses several important questions: What is the object's function? Why is it the way it is? Why was it conceived the way it was conceived?

For a designer who is inclined to take an inclusive approach, these questions are part of the repertory of requirements that have to be fulfilled by the object's composition. And this was the approach Calatrava has chosen. His bridges therefore embody a meaning that manifests its optimality but is also expressive of how this optimality is brought about and, last but not least, why optimality in this respect is a good thing. Bridges, in this sense, are symbolic objects. They incorporate meaning. This meaning can be didactic in that the articulation and configuration of their parts respond to the question of why they were made the way they were made, why they were given particular forms, why they are composed of particular materials. But in responding to the question of why making bridges optimal is a good thing, Calatrava, as we will see later, goes so far as to suggest an overarching attitude to the world, and, perhaps even more, tries to put forward an answer to the question of what makes a good life.

Calatrava's "universality" — his commitment and ability to respond to, rather than evade or trim down, this chain of questions by combining technological intelligence with poetry — has made his bridges so appealing, enhancing the sense of identity and cultural significance of the place where they were introduced and celebrating as collective representations the liberating power of creativity, hope, and community.

Opposite: Bridge over the Hoofdvaart, Hoofddorp, Netherlands.

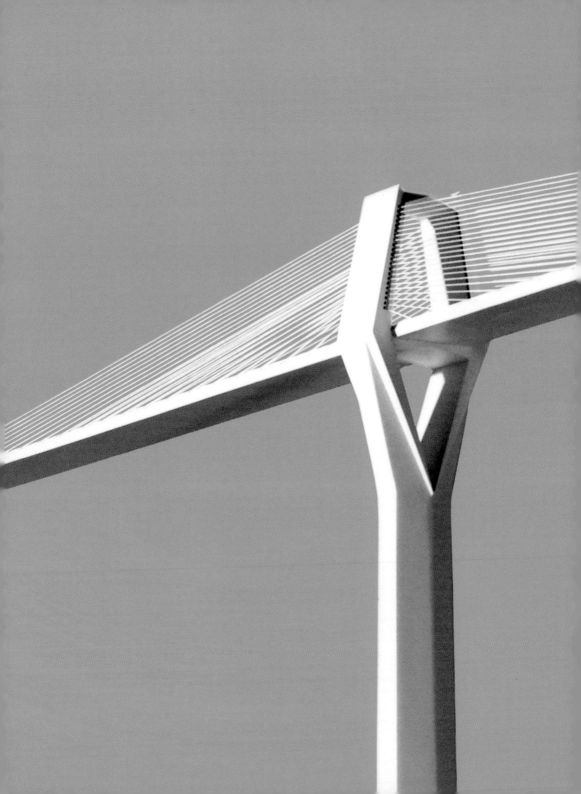

1
Alpine Bridges

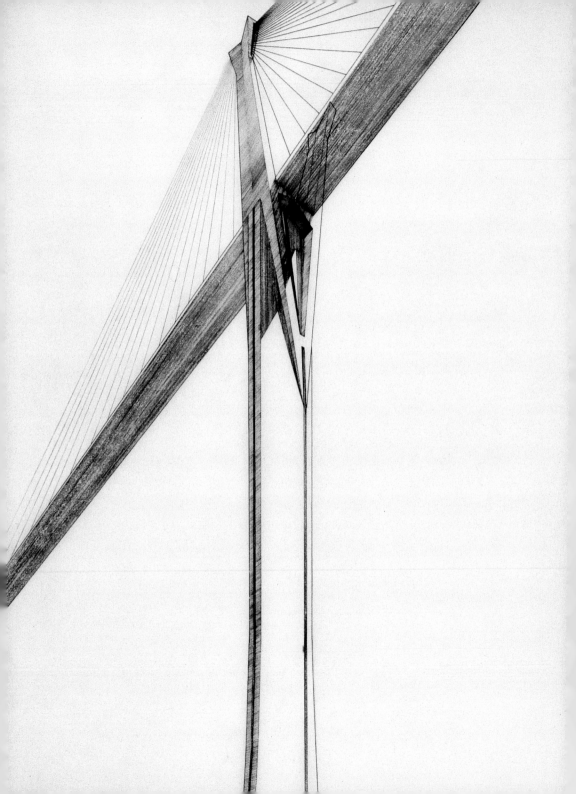

1 Alpine Bridges

When Santiago Calatrava arrived in Zurich in 1975 to study at the department of Civil Engineering at the Swiss Federal Institute of Technology (ETH), he was already qualified as an architect, having studied architecture between 1969 and 1974 and then urbanism at the Escuela Técnica Superior de Arquitectura de Valencia. At first glance, entering a department of engineering after studying architecture might seem dilettantish. Yet, a closer look into Calatrava's activities since he graduated from his high school in 1968 shows that the choice to study in an elite school of engineering at that moment was part of a consistent path of exploration.

The path began in Valencia with a short stint at the Valencia School of Arts and Crafts, which prepared Calatrava to master techniques of quickly grasping, through sketches, the outward appearance of physical objects. During his later architectural studies Calatrava began to employ this knowledge to become familiar with the world of built forms characterized by an apparent freedom of spatial configuration, such as Le Corbusier's Ronchamp or Iberian vernacular constructions. What fascinated Calatrava in those objects was the prospect that behind their apparent formal freedom were structure and method. To resolve this enigma he tried to grasp them by representing them, using, on the one hand, the traditional sketching techniques

Opposite: Bridge concept, IABSE symposium, 1979.

that he had learned in art school, and on the other hand the classic method-ology of descriptive geometry with which he had become familiar at architecture school. The next logical step in the same direction was to inquire into these forms by applying more rigorous methods that went beyond representation and dealt with the explanation of their genesis; thus his decision to join the ETH in Zurich.

Switzerland was familiar to Calatrava, who had often visited on vacation, during which he had had the opportunity to see and admire the bridges of Robert Maillart, the great pioneer of modern engineering. ETH was also familiar; its name is world-famous as an institution pursuing a rational, systematic approach to architecture with particular emphasis, since the days of Gottfried Semper, on structure and building technique. Albert Einstein was associated with the institution, as was Carl Culmann, a figure less well known to the broad public but of major importance to engineers.

Calatrava's theoretical interests in the methodology of design became clear when, soon after graduation as an engineer in 1979, he began working on a doctoral thesis, which he completed within two years, in 1981. Its title was *On the Foldability of Space-Frames,* and it dealt with how one could generate systematically, through analytical techniques, the configuration of structures that could take many forms by moving, opening, and closing. The study sounded very abstract; however, it turned out to have a major impact later in Calatrava's professional practice, making him a master designer of spectacular moving structures, waving roofs, and rippling walls. In addition, the study exerted an influence on Calatrava's work by helping him to con-ceive the intricate configurations of his buildings and bridges. Because these folding structures feature moving rods, they can be seen also as complex three-dimensional compasses, devices through which one can trace intricate forms of curved surfaces in three dimensions.

The thesis suggested that one could reduce the creation of all forms to a combination of a few basic geometrical elements. This idea left its trace in the systematic combinatorial manner in which Calatrava's mind very often works when he designs. However, it did not become a habit of mind. On the contrary, it seems that Calatrava soon realized that given the human limitations of time and memory, the idea of relying exclusively on rigorous analysis in order to design was unrealistic. Instead of unprecedented creations, such an approach could easily lead to a labyrinth of endless

combinations without exit. Soon Calatrava, still a member of the faculty of ETH, embarked on a diametrically opposed approach to design that depended on analogy. In contrast to analysis that employs abstract computational symbols, analogy recruits figures of concrete objects. For Calatrava, these objects would be mostly animals or human bodies. Thus, soon after the completion of his thesis at the ETH, in the preliminary studies of a pylon for one of his first bridges, the Biaschina Viaduct, Calatrava sketched the human figure from which the pylon would take its form. In the following years, Calatrava would fill up numerous notebooks primarily with the human form sketched to resemble a folding or a supporting structure.

However, as we will see later, in the design of his bridges as well as any other kinds of structure, Calatrava did not completely replace analysis with analogy. While many designers hold analysis and analogy as disconnected, antagonistic divisions of intellectual labor, Calatrava brought them together as complementary mental tools and adopted them as two specialized intelligences coexisting in collaboration.

Walensee Bridge Walensee, Switzerland, 1979

The first serious encounter with bridge design occurred during Calatrava's third year of studies at the Escuela Técnica Superior, in the course called Bridge Construction. As part of a class exercise, Calatrava designed a bridge for a site near Walensee facing the gigantic "barren peaks" of the Kurfirsten Mountains, a site awe inspiring to visitors and challenging to a young designer because of its natural "grandeur," as Baedeker's guidebook describes it, but also because it includes a number of true engineering features, including tunnels and passages cut into the rock. Calatrava employed an elliptical, tubelike structure reminiscent of a long-span continuous-beam highway bridge of reinforced concrete designed by Paolo Soleri in 1948 and exhibited in the Museum of Modern Art in New York in 1949. In the spirit of the times, Soleri's bridge was much admired for its plasticity

expressing the unique "natural" capabilities of concrete as a construction material easily moldable to achieve graceful continuous surfaces. However, Calatrava's elliptical tube form emerged explicitly out of structural considerations, marking the beginning of his new scientific exploration into what we might call morphogenesis. Tubular structures perform excellently from the structural point of view because they evenly distribute compression and tension; as D'Arcy Thompson observes they are manifest in nature in the "tubular limbs" of birds, insects, and crustaceans. Several years later, Calatrava described this first "opportunity": "The exercise was to design a bridge spanning from a mountain tunnel across a ravine. My design proposed continuing the shape of the concrete tunnel shell, while permitting the sun to illuminate the roadway. I achieved this by cutting and modifying

Sections and perspective drawing.

the shape of the tubular section to the structural requirements of the span." One of the possibilities of a tube structure was that such cuts could freely be made in its surface without affecting its strength. Further, the tubular shape supplied an interesting technological solution that went against the grain of the traditional "free cantilever structures" approach, which applied the supporting compressive forces below and used the deck of the bridge to take the tensile forces. Calatrava's scheme, however, carried the tensile forces *over* the pylon supports by the upper portion of the elliptical shell, while the compressive forces were absorbed along the road deck. Responding to faculty criticism concerning the problem of "transmitting sheer forces into the pylon support," Calatrava modified his solution to extend the pylons to the transverse limits of the elliptical shell to better take

the shear forces over the pylon, making it resemble, even more than before, human bone structures and their joints. The project was indeed a prelude to later investigations into the morphology of optimal structures that used as yet untapped possibilities of material and less restrictive forms than the elliptical shapes employed in the Walensee Bridge. In addition, although Calatrava provided no sketches showing the impact of his bridge scheme on the surrounding site, looking at the model one can easily see how its tubular, bonelike structure would rest felicitously in the midst of what Ruskin called the "mysterious" masses of the Alps. Despite the contrast of geometry —angular in the case of the stark summits of the Kurfirsten Mountains, curvilinear in the case of the bridge — they both shared a deeper affinity in that they were both natural, their forms implying power and motion.

Above: Diagram showing tensile forces carried over the pylon support by the upper portion of the elliptical shell. Compression forces are received at the level of the road deck.

Following pages: Model.

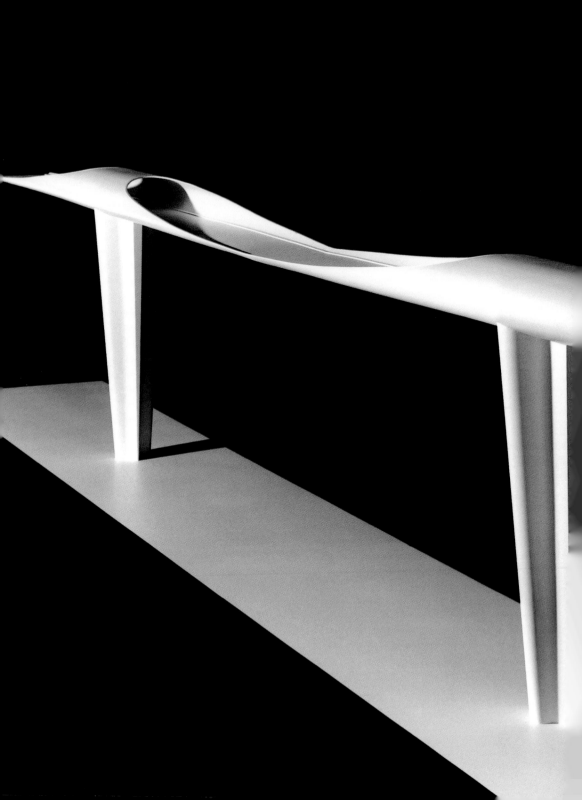

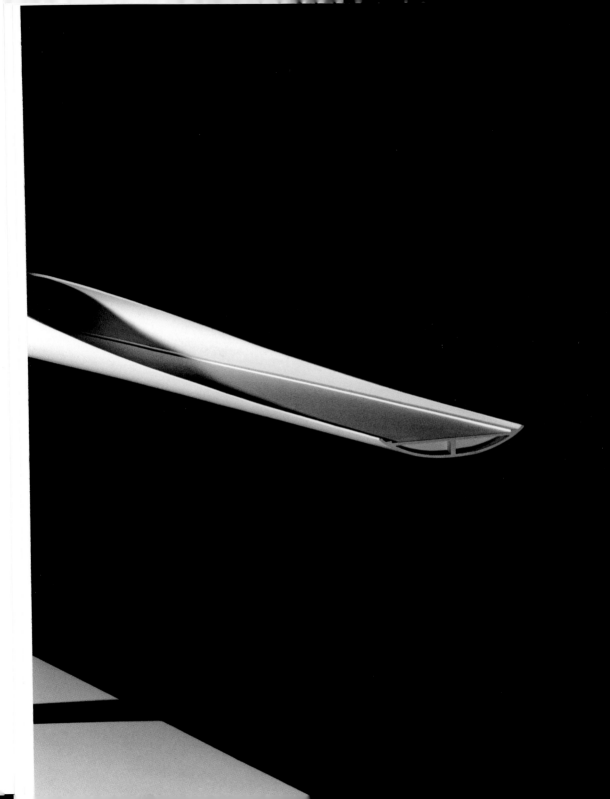

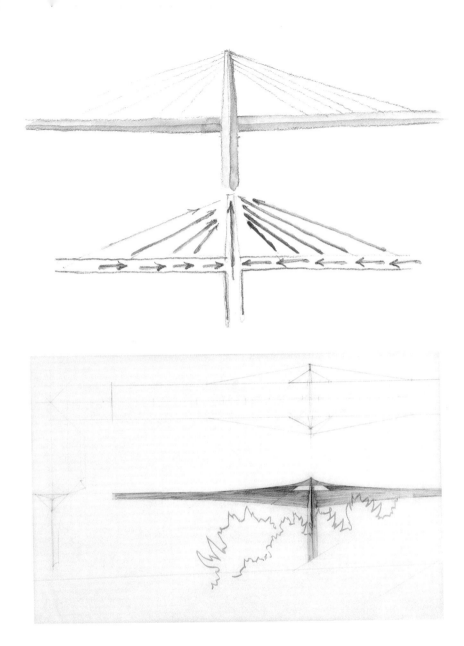

Top: Diagram showing embedded tension
cables freed from the lateral shear walls.

Bottom: Plan, elevation, and section.

Opposite: View of highway deck from below.

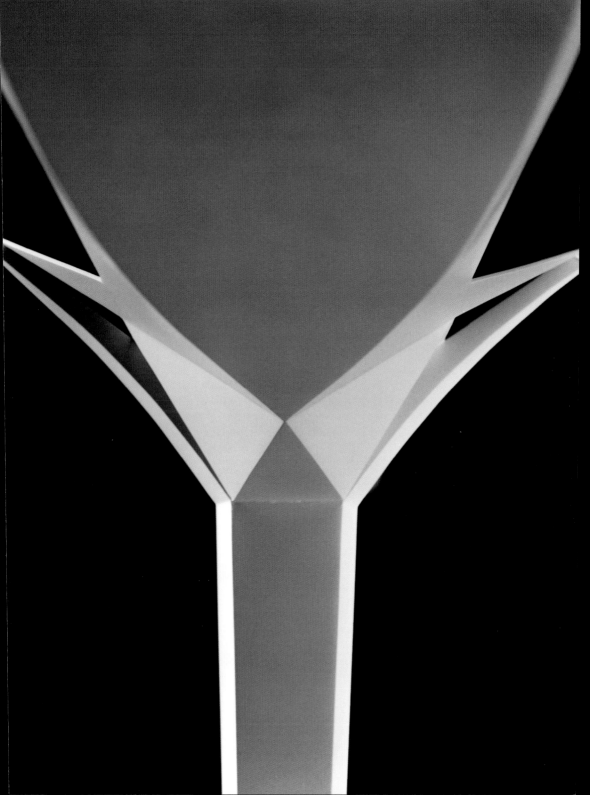

Biaschina Viaduct Biaschina, Switzerland, 1979

Soon after the completion of his thesis at the end of the spring of 1979, Calatrava, now a licensed civil engineer, was engaged by the ETH as an assistant in the Department of Architecture. His involvement with this department did not interrupt his attachment to bridge design. He continued thinking about bridges as a poet writes poems without the need of a client or an immediate plan of publication, trying to find free time for it. As a member of the ETH staff, he was committed to reside in Zurich. Robertina was preparing for her law exams at her parents' house near Locarno, in southern Switzerland, and caring for their boy. This arrangement necessitated long hours of commuting by train every weekend. But the train rides also supplied the free time Calatrava needed for developing his ideas on the design of bridges.

Calatrava has described how during these moments, "after passing through the Gotthard Highway, the train's spiral descent through the mountain tunnels to the valley below provided several stunning views of the Biaschina Bridge, which was being built at the time for the transalpine Gotthard Highway. During these trips I began to sketch my own ideas for the design of a bridge" — the Biaschina Viaduct.

The initial thrust of the project was to further explore issues that had emerged from Calatrava's doctoral thesis. Using towering pylons, he continued to develop the free cantilever concept to achieve a clear span of 300 meters, freeing the embedded tension cables holding the deck of the highway from the prestressed concrete shells of the pylon supports. As a result, the structure became even lighter and, given its scale and setting, even more sublime. But Calatrava had no time to ponder the implications of this scheme. A request came to design one more Alpine bridge, the last of this series.

Opposite: Model of single-deck highway.

Following pages: Elevation of bridge in the Levantina valley.

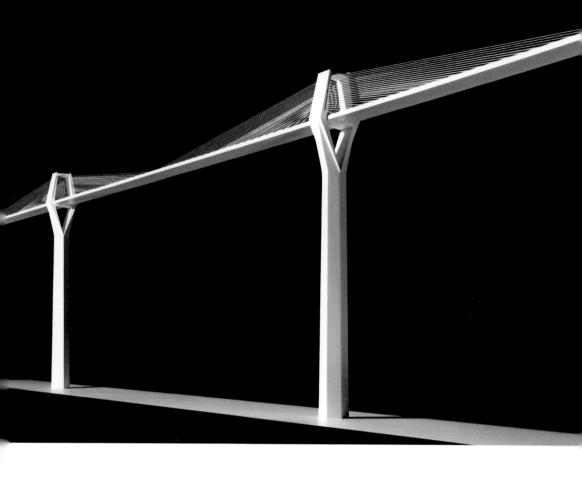

Schemes for the IABSE Zurich, Switzerland, 1979

During the fall semester of 1979, Calatrava conceived a series of schemes that were produced at the request of and presented by Professor Christian Menn of the civil engineering department at the ETH for the International Association for Bridge and Structural Engineering (IABSE) at their fiftieth-anniversary symposium in Zurich. Menn, who had worked with Maillart, was presenting a lecture on modern bridge design and construction at the symposium. He asked Calatrava, who was then still working as an assistant in the architecture department of the ETH, to design a bridge that would be presented during the lecture. Calatrava generated a series of tall pylon bridges, 300 meters high, with a clear span of 250 meters, for single- and double-deck highways crossing deep Alpine valleys. Out of these schemes Menn chose two, including one signed by Calatrava, which he presented at the symposium, failing, however, to mention the name of the designer, vaguely referring to a "Spaniard" assistant. The schemes Calatrava conceived elaborated upon previous ideas but with greater focus on the diverse possibilities offered for shaping the head of the pylon and connecting to it the cables. In contrast to the Biaschina Viaduct, where Calatrava did not explore the pylon cross sections, here he generated a variety of alternatives delving into the possibilities and effects of the cross, double-T, rhomboid, and hexagonal configurations. While the search for these variations appears to have been a combinatorial experiment, the resulting humanlike figure, with raised arms seemingly holding the cables like an archaic god aiming rays from his raised hand, suggests that Calatrava was also employing the poetics of analogy.

Opposite: Drawing of the 300-meter-high pylon of a single-deck highway. Human figures at the bottom of the pylon indicate the scale.

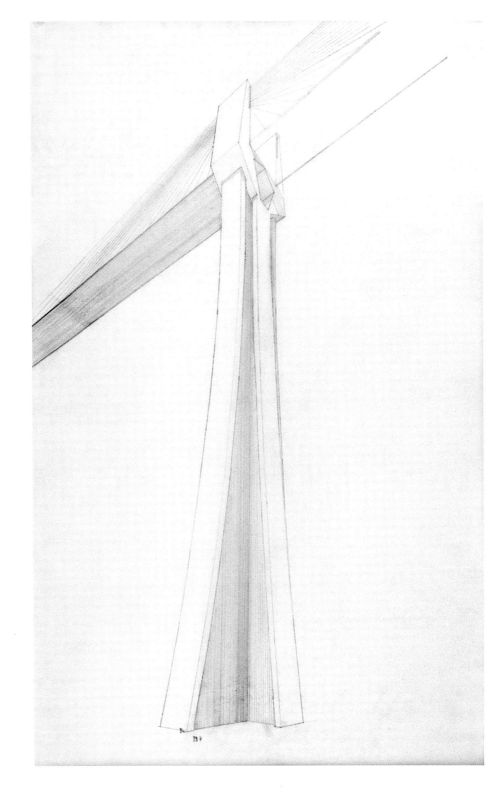

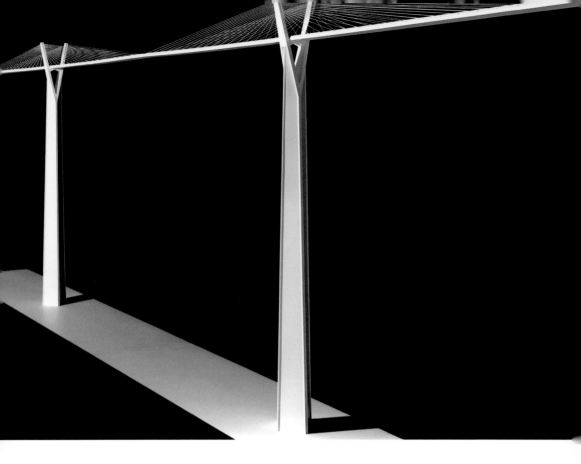

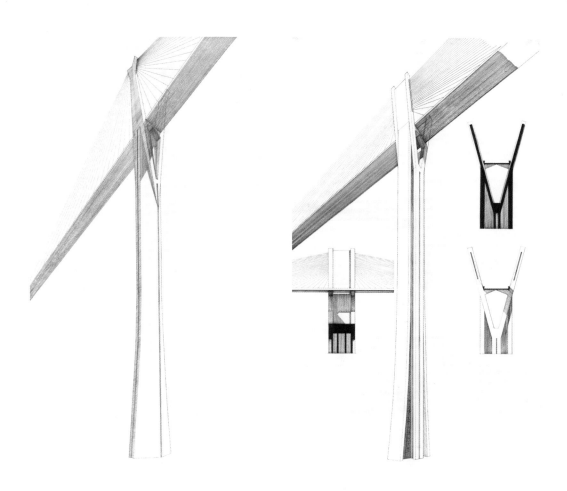

Opposite: Model.

Above left: Single-deck highway with arms reaching high above the deck (presented at the IABSE symposium).

Above, right: Drawing and section of single-deck highway. Drawing presented at the IABSE symposium and signed on the left side of the deck by Calatrava.

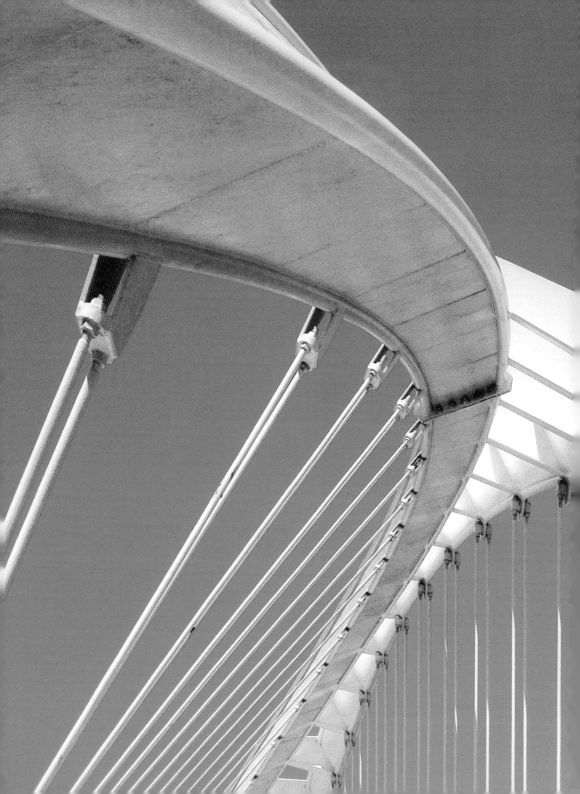

2 Rethinking Bridges

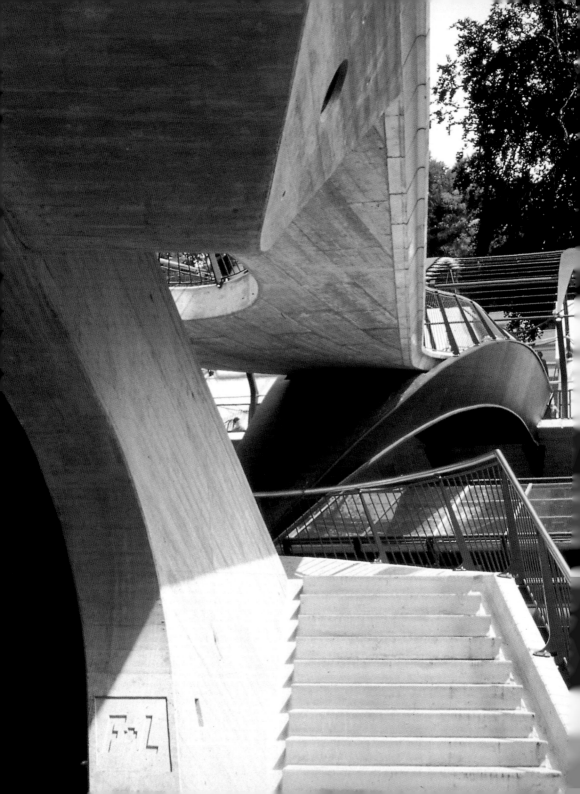

2 Rethinking Bridges

The years of the Alpine projects were for Calatrava a period of inquiry into the possibilities of generating form through rational methods of science. But it was also a period of mastering the basic elements, problems, and solutions of a very specific object, the bridge. The first exercises, as we have seen, were explorations into the essential structural aspects of a bridge — the deck, the pylon, and its shape — and the relations among these components. The ETH exercises were aimed at achieving optimal forms; that is, forms minimizing resources and maximizing performance, an objective Calatrava attained by trying alternative combinations of the bridge components. The schemes that were finally chosen expressed the idea of optimality through large-scale spanning, bare minimum structure, lightness of materials, the differentiation of structural functions into categories of compression and tension, assigning these differentiated tasks to specialized components, and

Opposite: Detail of footbridge at Stadelhofen Railway Station, Zurich, Switzerland.

Above: Stadelhofen Railway Station, section showing bridge.

profiling them to reduce them to essential materials. Even if some of these Alpine exercises involved analogy, the figurative thinking was only in the background. In the years to come, systematic search and combinatorial exploration would continue to characterize Calatrava's design thinking, but would always recede more and more into the background as analogy came to play an increasingly decisive role in his work.

During the four years that followed his period of study at the ETH, Calatrava became involved with a variety of design projects: entire buildings, parts of buildings (roofs, doors, enclosure walls, and balconies), and a significant medium-scale complex, the Stadelhofen Railway Station. Among those projects there were only two bridges (though the Stadelhofen Railway Station complex, a project driven by the articulation and representation of movement, included small pedestrian bridges crossing over the rails). But one can discover in any of these early projects, whatever their function and scale, the idea of a bridge emerging in its most elementary sense as a link and in its most abstract problem-solving sense as an optimal structure, as if the projects were meditations on bridges to come.

Opposite: Human figures and bridge diagrams from the notebooks of Calatrava. Left to right, top to bottom: 2002 notebook (number 1102), 1999 (204), 2003 (517), 2003 (509), 2003 (504), 2003 (505), 2000 (716), 2000 (716).

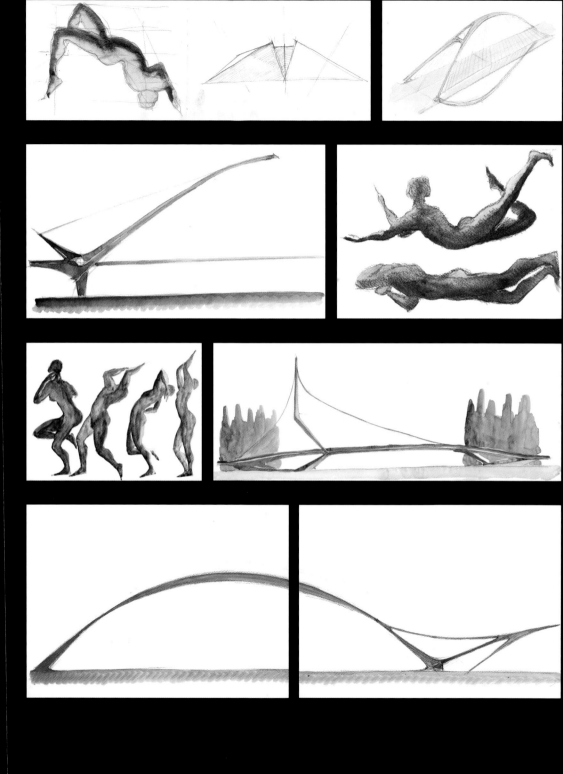

In the most basic sense a bridge is a physical object that connects two or more locations, providing passage over a natural or artificial gap — a view reflected in Calatrava's early work on the Alpine bridges. A bridge is composed of a transverse bearing component, generally referred to as a deck, that enables moving objects, pedestrians, vehicles, or liquids to pass from one place to another, and a structure component that channels the loads of the crossing objects, together with those of whole structure, to the ground. This clear but reductive description of a bridge gives the misleading impression that it is made out of an assemblage of individual standard elementary parts. It does not convey the underlying give-and-take process that dictates relationships among parts. It does not suggest that parts can be fused into a single member and that members can be integrated into a single "whole," what engineers in the nineteenth century called *Gestaltungskraft*. And it does not bring to mind other considerations that make a bridge a complex object that not only carries its own weight and that of the objects that cross it but also resists wind, rain, and seismic forces. Finally, this definition fails to address the fact that besides decks and support bridges require specialized passages for pedestrians and vehicles, parapets and lighting features, and connections to paths and roads on the ground. It is toward this complex synthesis of multiple factors contributing to the design of a bridge, beyond simple reductive optimal solutions, that Calatrava turns around the middle of the 1980s.

Opposite: Details of bridges from the notebooks of Calatrava. Left to right, top to bottom: 2000 notebook (number 503), 1998 (711), 2002 (704), 1995 (208), 2000 (503), 2002 (506), 2002 (704), 1999 (901).

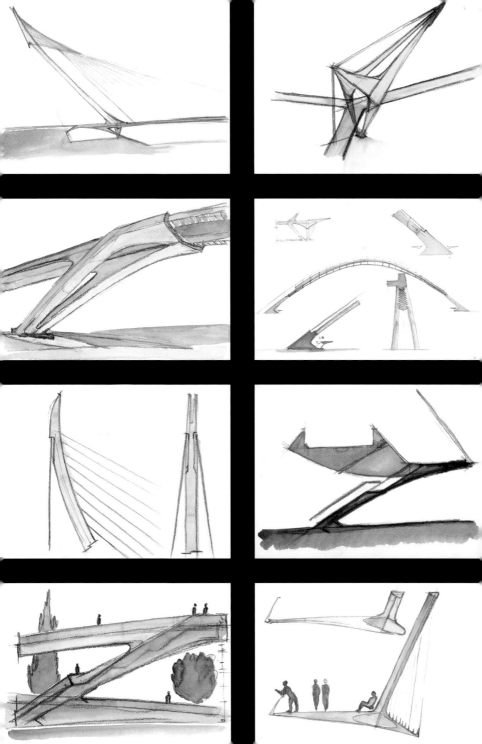

Caballeros Footbridge Lerida, Spain, 1985

Responding to his own desire for innovation and to the constraints of the site for the Caballeros Footbridge, Calatrava explored a structure type radically different from the repertory of the Alpine bridges. An entry to a competition for the city of Lerida in Spain, this was the first project to reveal Calatrava's highly original approach to the bridge as object.

The scheme was conceived as an extension of the Calle des Caballeros, which ends at the city's medieval walls and connects the old urban core with the woods and fields on the other side of the Segre River. What is rare about the structural solution is its asymmetrical single pier, which was dictated by the unstable nature of the terrain of the wooded bank opposite the town. Calatrava proposed placing the single steel pylon on a pile foundation on the bankside, where the soil was good, and cantilevering it off a reinforced-concrete support. The light steel and aluminum walkway, which spans 140 meters, is suspended over the river by cable stays spread out like a fan

from the pylon's head, tilted away from the town. The back stays are arranged in a radial form. Enclosing the walkway is an aluminum canopy with glazed sides.

Despite its complex and unorthodox configuration, the structural solution is rational. The uncommon asymmetry of the scheme is determined by the special topographic conditions. As with the Alpine bridges, the structure, transparent and light, is kept to a bare minimum. Its components are differentiated, each assigned the specialized tasks of compression and tension, and the materials were chosen and allocated to these components to carry out tasks specifically fitting their nature. The profile of the single pylon is shaped to provide strength where and when it is essential. The cables' fan pattern creates an optimally efficient distribution of weight thanks to the harp pattern, where the cables are parallel. The tilted pylon reaches over the deck closer to its middle, an arrangement that has obvious structural benefits, while the back-stay cables stabilize the structure.

Opposite: Model.

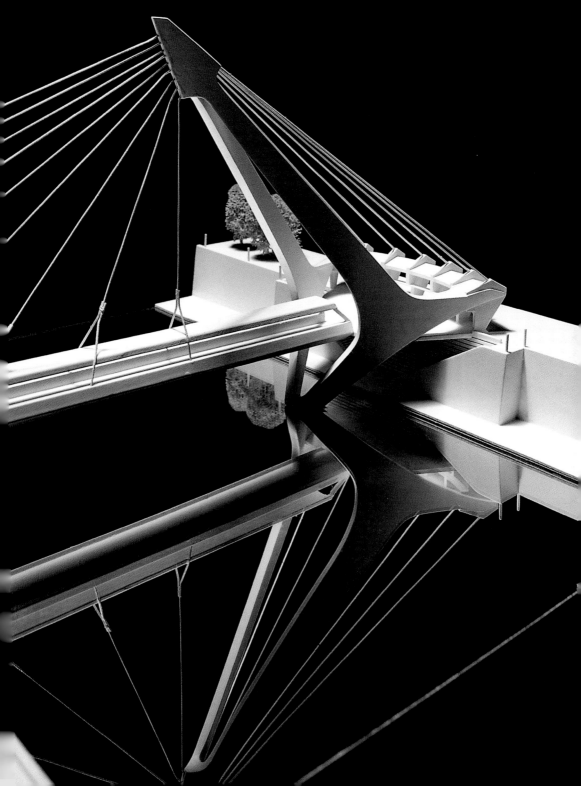

This is the first project in which Calatrava uses the tilted pylon motif. Atypical for bridges, it is a structural configuration most frequently encountered in cranes, and the inclined pylon hoisting the bridge's deck resembles a cantilevered boom. This motif, together with the other characteristics of the scheme, responds to the objective of optimality. However, the "expressiveness" of the form, resulting from the articulation of the structure, reveals another intention: to explain how the structure works, how it is made optimal, why it is given its form, and why it is assigned its materials.

Calatrava would go on to employ this inclined single pylon motif so frequently, in fact, that it would almost become his signature theme. The structure of the Pontevedra Motor Bridge is also based on the cable-stayed bridge motif, with a tilted, steel-headed pylon cantilevered off a reinforced-concrete support built on one bank of the river. Once more the idea is rational, the single-pile scheme leaving the section supported by the cable stays free of piers, thus offering a wide, clear channel for navigation. The project was designed in 1987 as a competition entry for a bridge spanning the Miño River in the Pontevedra region of Galicia, Spain, near the border of Portugal. The maximum span of 130 meters is approximately the same as that of the Caballeros Footbridge, though the total length of the Pontevedra Bridge is 510 meters (for much of this length, the central load-bearing element, a concrete box girder, is supported by pairs of reinforced-concrete piers).

But the Caballeros Footbridge was not a formula for imitation. It was an important experiment that anticipated the more advanced and adventurous schemes to come, such as the cable-stayed bridges on the Hoofdvaart River in the Netherlands and the Light Rail Train Bridge in Jerusalem. But, as we will see later, the motif expands to serve not only objectives of structural optimality and didacticism but also epistemological and moral imperatives within the framework we will call the "poetics of movement."

Opposite, top: Model.

Opposite, bottom: Plan and elevations.

Following pages: Model of Pontevedra Motor Bridge.

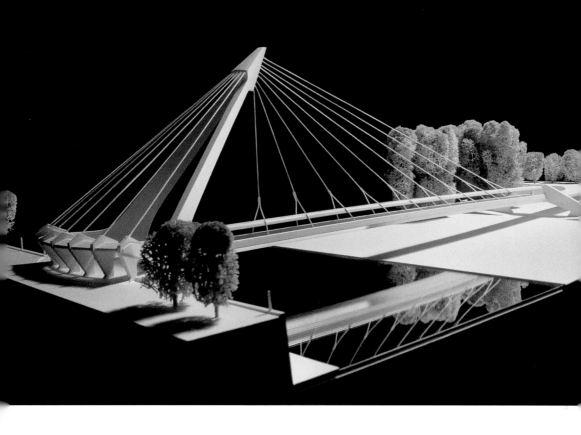

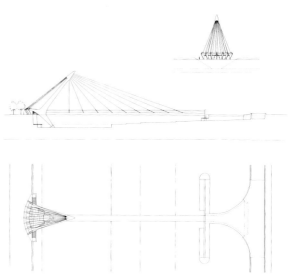

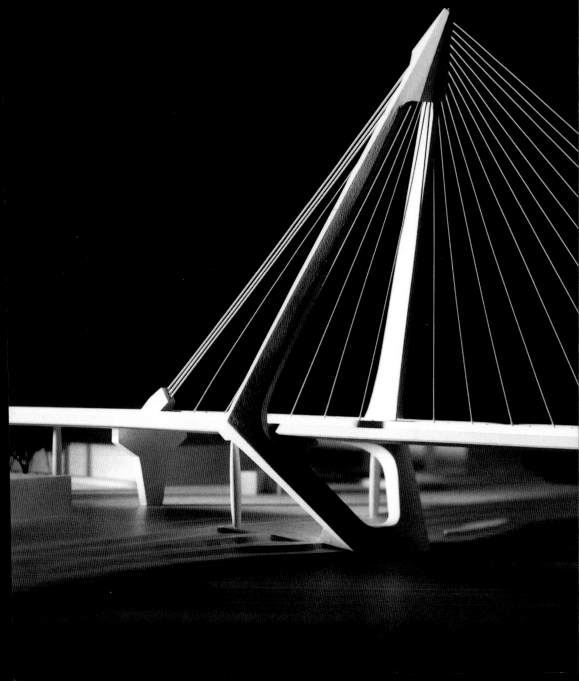

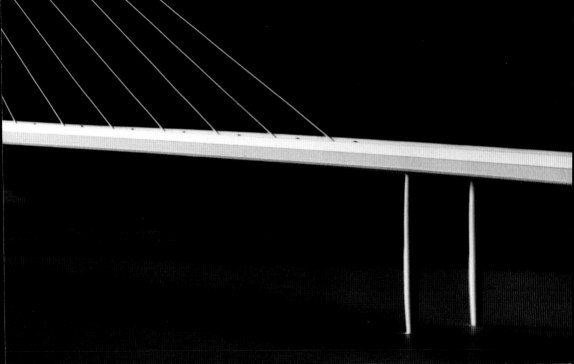

Bach de Roda Bridge Barcelona, Spain, 1985–87

The idea of movement in structure figures prominently in the scheme for the Bach de Roda Bridge in Barcelona. Commissioned in 1985 and designed at the same time as the Caballeros Footbridge, the configuration of the Barcelona Bridge appears very different. Yet, the imperatives to give to the bridge's structure an optimal form and to explain through its form how its structure works appear here as they do in the Caballeros Bridge. The structure is bare, with a transparency emphasized by the contrast between the bracing arches and the lightness of the strings supporting the deck. The tilted motif of the pylon is echoed here in the 60-degree incline of the secondary steel-stiffening arch. The division of labor between compression and tension is clearly expressed. The volume of the double arch strengthens the structure where needed so that forces are channeled in the most efficient way, minimizing costs and risks. Concentration of loads and slimness of sections are maximized, giving the structure a streamlined appearance that embodies the optimal diagram of operating forces.

But one can see in the Bach de Roda Bridge more than a static diagram of forces. The energy expended to create the structure is not lost. It is stored in the structure, embedded within its configuration. It has become potential energy, carrying with it the implication that under certain conditions it can be transformed back into kinetic energy, leading to movement. To quote Calatrava, "Mobility is implicit in the concept of strength . . . strength is crystallized movement." Hence the sense of movement one has when reading the immobile structure of the bridge.

Movement is present in the Bach de Roda Bridge not only metaphorically: real movement, vehicular and pedestrian, played a key role in the conception of the general plan of Barcelona, within which Calatrava's bridge commission was a crucial component. The commission — the first to demonstrate Calatrava's ideas about bridges — was seen by the city's leaders as a means to renew the urban

Opposite: Detail of one set of double arches.

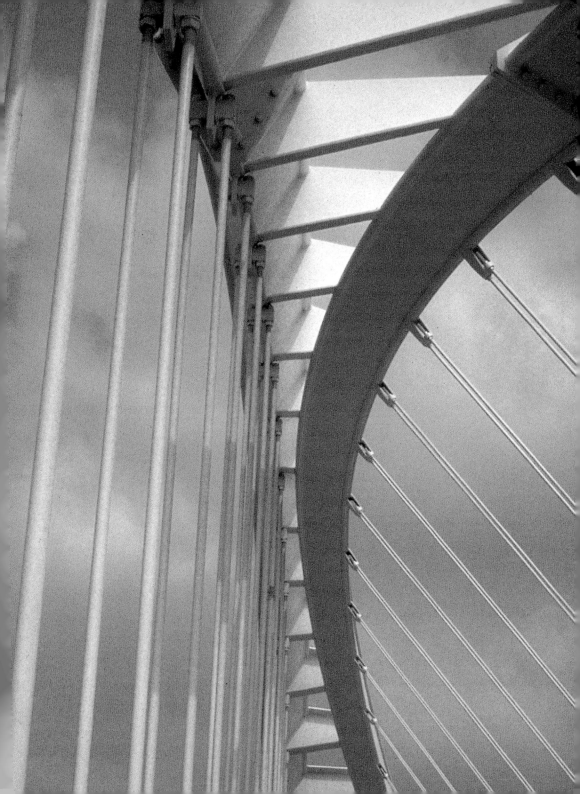

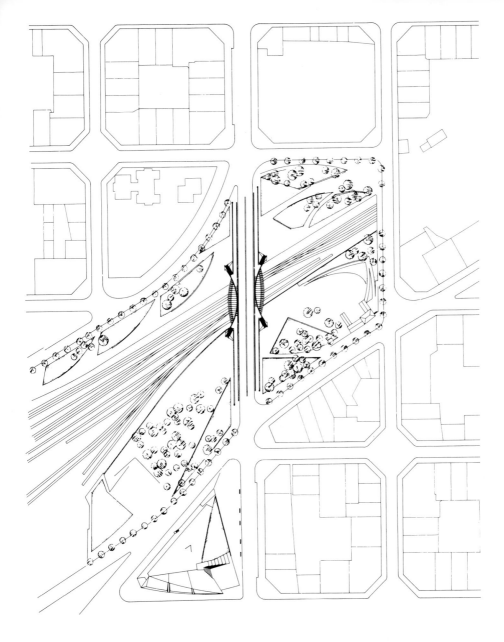

Above: Site plan.

Opposite: Section.

Following pages: Model.

infrastructure, taking advantage of the occasion of Barcelona's selection as the official site of the 1992 Olympic Games. Although an international event, the Olympics were seen as an opportunity to improve local conditions by increasing the accessibility of those ailing impoverished areas that were not well connected to the city's transit system. Among these impoverished areas were the site of Sant Andrea to the north and San Marti to the south, on the fringes of the Cerda town plan, and isolated by a railway line that the Bach de Roda Bridge was intended to connect. The program also included the construction of a new railway station nearby and the transformation of the railway's flat, wide embankments into a continuation of the

Parc de la Clot, thus creating one of the city's most expansive green areas.

The bridge, 128 meters long, is composed of three parts: a central segment, 45 meters long, above the railway line; and two lateral segments, 25 meters long, which pass through the park. The lateral segments are connected to the green areas by four staircases, which rise from the bases of the inclined arches, above track level. The structural elements are foundations on piles (due to the lack of solidity of the terrain), supports (uprights, intermediate, and central supports), superstructure, arches, and central beams. The concrete uprights, with a sinusoidal plan in the central part, are formed by barrier walls inclined forward. The intermediate supports, about

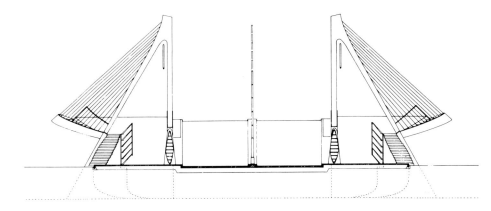

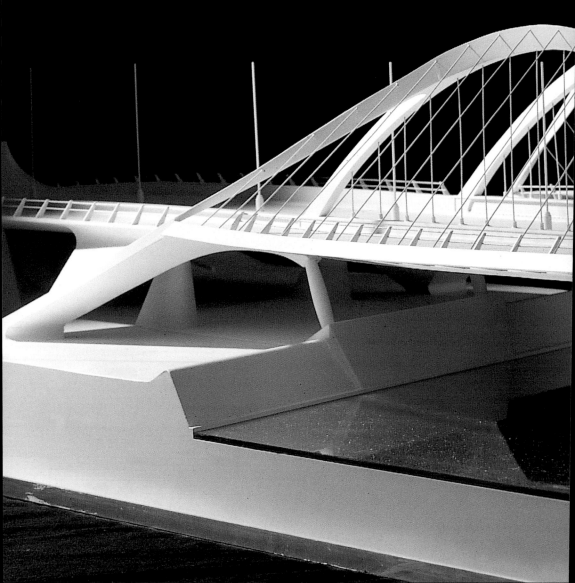

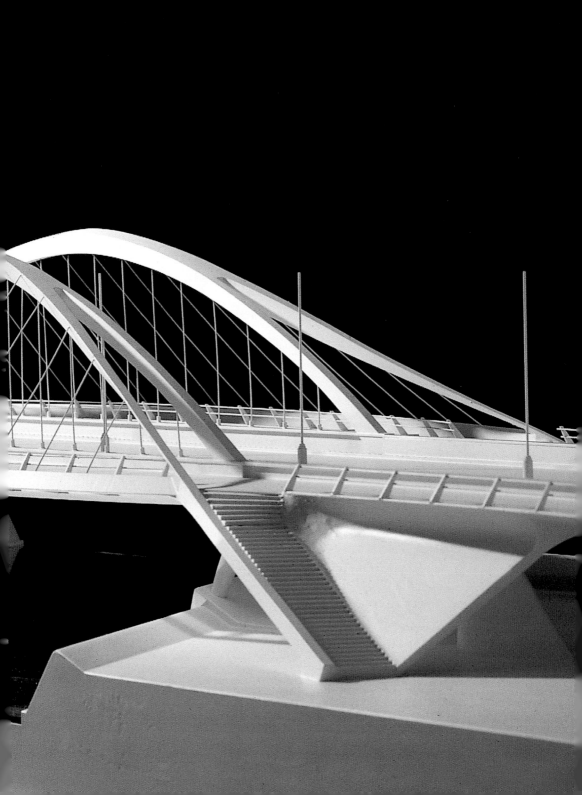

4 meters high with a truncated cone form, transmit the vertical forces to the foundations and stabilize the bridge laterally. The central pendular supports are monolithic granite columns. The two main steel arches are tied by the main road-deck girders. The girders support the cross beams beneath the concrete roadbed and pedestrian walkways. The 46-meter span structure rests on four aerodynamically shaped reinforced-concrete pylons. Each of the main arches is stabilized by a secondary steel-stiffening arch inclined at an angle of 60 degrees, supported by attenuated abutments. These secondary arches act as lateral stabilizers, eliminating the need for a truss between the main arches.

The sense of movement is strengthened by the contrast between the direction of the bridge and the Cerda grid, as well as by the continuity between the bridge and the adjacent streets. With its double arches spanning the railway gap, the bridge works as a landmark channel that visually and physically links the two sides of the remotely situated park.

The sense of movement is further emphasized by the differentiation between vehicular and pedestrian circulation. The vehicular traffic runs between the main arches, while pedestrians walk along the sides, flanked by the main arch and its corresponding supporting arch. But the various movement systems are not just specialized channels, arranged one alongside the other. There is, one might say, an active cooperation among conduits within the structure. The stepped entrance to the footpath, the ascending stair, and the ascending arch join to form a multifunctional route within which the integrity of each flow is equally preserved. The flow of pedestrians penetrates through the volume of the concrete supporting arch in the middle of the flow of forces, at exactly the spot where the penetrating path does not weaken the support structure — in other words, where the presence of material is redundant. Similarly, the channel for lighting is embedded in the handrail channel following the same principle of differentiating channels between flows with spatial cooperation between them.

Opposite: View of staircase and deck under one set of double arches.

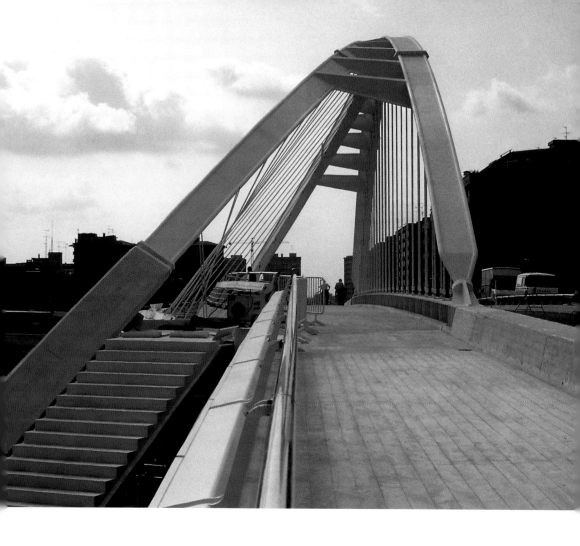

On the other hand, this emphasis on movement does not turn the bridge into a mechanical viaduct. Calatrava intentionally shaped and located the pedestrian deck paths so that they become pleasant walkways and even gathering places rather than runways. The pedestrian areas widen in the middle of the bridge in the form of a bow, the widening of the deck offering a kind of suspended piazza allowing panoramic views of the neighboring areas. The paths run under the volumes defined by the suspension cables and the double arches, appearing to the pedestrian as transparent enclosures. The piazza, or rather belvedere, has access to the park through concrete stairs. Its curved shape follows the curve of the secondary arches' abutments, generating a feeling that the bridge is part of the city's linear park system rather than a technological disruption, as infrastructure projects so often are.

View of bridge's structure from within double arches.

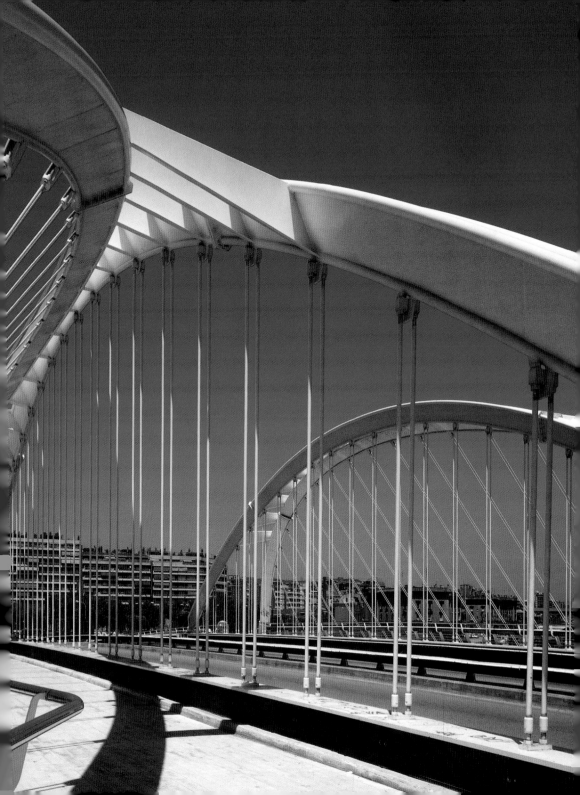

Oudry-Mesly Footbridge Crétoil-Paris, France, 1987–88

Very similar in form to the scheme of the Bach de Roda Bridge, the Oudry-Mesly Footbridge for Créteil-Paris, France, was commissioned at the beginning of 1987 — the year the Bach de Roda Bridge was constructed — and was built between February and September 1988. Spanning the Paris-Bonneuil motorway to the southeast of Paris, it was intended to connect two housing developments.

The total length of the bridge is 120 meters, the maximum span is 55 meters, and the depth of the steel arch is 8 meters. The steel girders are hung from twin steel arches and carry a series of cross beams on which the concrete walkway lies.

A steel fillet at each end of the arch structure transfers the vertical load to the reinforced-concrete foundation and the horizontal load to the steel girder. The suspender cables, supporting the exposed ends of the cross beams, are connected to the arches by sockets and welded gusset plates.

Opposite: View of bridge with urban context in background.

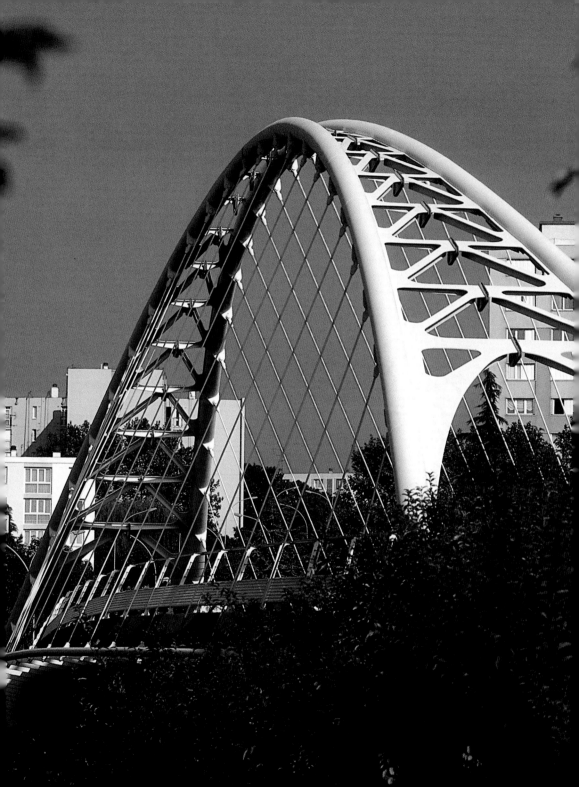

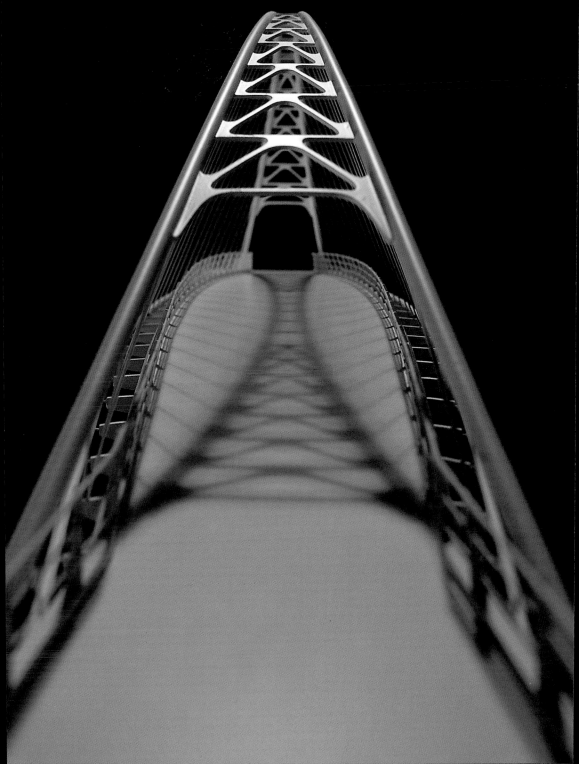

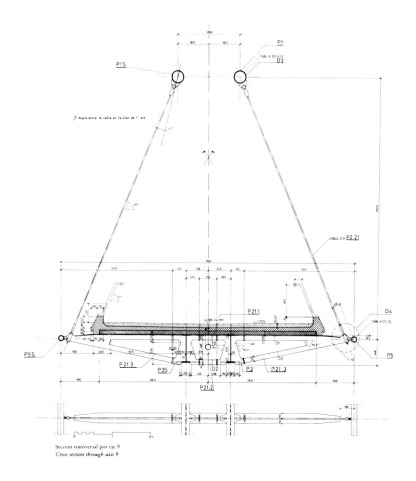

Seccion transversal por eje 9
Cross section through axis 9

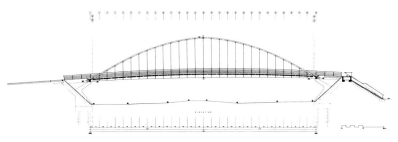

Opposite: Model.

Top: Detail of structure.

Bottom: Elevation.

Gran Via Bridge Barcelona, Spain, 1989

The Gran Via Bridge uses the Oudry-Mesly strategy, developed here into a "doubled," composite motif. In other words, one twin arch is followed by another supporting a twin box girder deck. The scheme is suitable for the longer bridge, the total length of which is 258 meters with a maximum span of 126 meters.

Model.

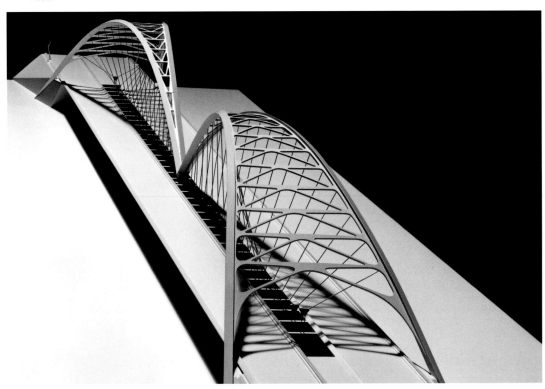

Ile Falcon Viaduct Sierre, Switzerland, 1993

The same twin-arch idea, appropriate as it is for large-scale projects, is employed once more in the scheme for the structure of the Ile Falcon Viaduct, a four-lane motorway bridge designed for a section of the Swiss national road network along the Rhone Valley in the canton of Valais. The project encompasses a stretch of 684 meters overall and is divided into three parts: the bridge itself, the area between bridge and tunnel, and the link to the plain on the opposite side. Four steel arches meet on a central pylon 5 meters wide, which is the only point of ground contact within the environmentally sensitive river area. To reduce interference with the banks, the bridge is slightly longer than requested in the competition brief. The two spans of 135 meters were deliberately extended in order to minimize any disturbance of the site's delicate ecosystem. The separation of the decks was intended to minimize structural mass and thus the shadow cast onto the riverbed.

Model.

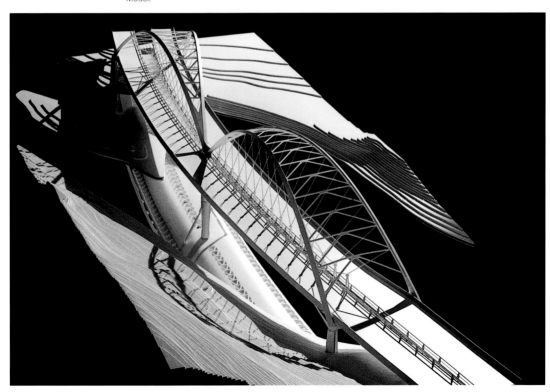

Öresund Link Malmö, Sweden/Copenhagen, Denmark, 1993

As the preceding two projects illustrate, large-scale programs limit scheme choices for a bridge structure. So for the 1993 Öresund Link, a competition entry undertaken with KHR Architects and Ahlgren Edblom Architects intended to span the strait between the North and Baltic Seas to connect Malmö, Sweden, with Copenhagen, Denmark, Calatrava again employed twin inclined arches joined at the top, which he developed further by doubling them into a composite motif. He combined this with a long, continuous deck, one third of which is suspended from the large arch. Here the deck channel is embraced by the inclined arches. The scheme is efficient and effective from the point of view of stability. Movement is again represented, this time on a monumental scale in the deck, which pierces and splices the arch. The maximum span was to be 630 meters, and the maximum depth of the arch 80 meters.

Model.

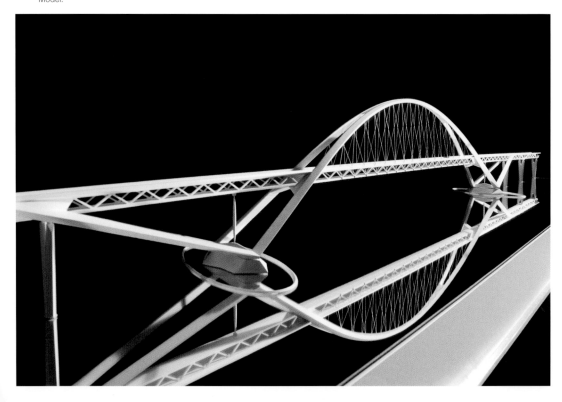

Poole Harbour Bridge Portsmouth, England, 1995

For the same reasons of size, the scheme for the Poole Harbour Bridge project, a competition entry in association with Dennis Sharp Architects, has strong similarities with the Öresund, featuring the same differentiation and articulation of movement channels. It is a steel structure with concrete abutments and piles. The deck's total length is 740 meters, with a maximum span of 270 meters. It pierces and splices a 44-meter-deep arch from which it is suspended, while accommodating pedestrians and vehicles from a connecting road that relieves Holes Bay of cross-channel traffic.

Rendering.

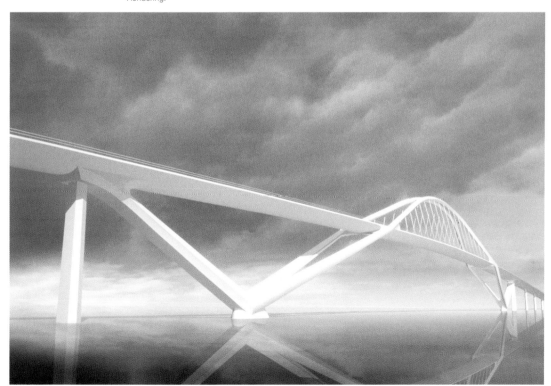

East London River Crossing London, England, 1990

The East London River Crossing also uses a single arch whose profile appears to be continuous from pier to pier. The arch works as a truss with a curved top-chord supported by the two cantilevered approach spans on the concrete pylons. This bridge over the Thames River was intended to connect the areas of Beckton to the north and Thamesmead to the south, relieving congestion on existing crossings in East London and improving access to the Docklands and London City Airport. Vehicular traffic is accommodated in the central span by a single tied steel arch placed in the middle of the divided six-lane roadway. The arch spans 300 meters, has a depth of 25 meters, and rises to a total height above the abutments of 103 meters. The road deck structure is a hollow box tube, and continues over two reinforced-concrete pylons that are placed 510 meters apart and set into the riverbed close to the banks. The suspender cables are spaced approximately 12.5 meters apart, and the total width of the bridge is 35 meters to allow for roadways, foot traffic, and bicycle paths. The gentle low arch of the main span presents no obstacle to London City Airport flight paths, and unrestricted shipping is ensured with the required 78-meter height to the soffit.

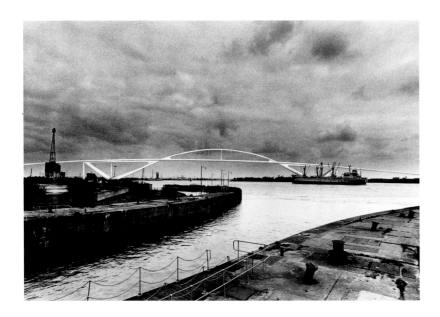

Above: Photomontage.
Opposite: Model.

Serpis Bridge Alcoy, Spain, 1992

The Serpis Bridge, named after the river it crosses, presents a configuration similar to that of the East London Bridge. The deck is suspended from a steel arch with a total length of 520 meters, a span of 210 meters, and a depth of 30 meters. In contrast to the East London Bridge, the loads of the deck here are transmitted to the arch via the cables and from the arch directly to the foundations. In 1994 a second version of this bridge was designed with a total length of 383 meters and a span of 280 meters across the Serpis River. The suspension steel arch is inclined with the statically ideal slope of 70 degrees, to support the deck. This inclined canted arch motif developed out of the Volantin and La Devesa Footbridges and anticipates the design for the Bridge of Europe, also known as the Pont d'Orléans.

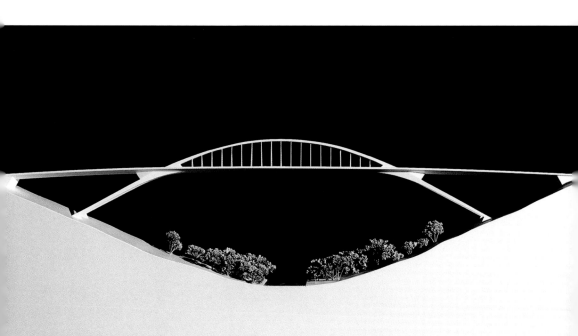

Sundsvall Bridge Sundsvall, Sweden, 1995

The 1995 competition project for the 2,100-meter-long Sundsvall Bridge in Sweden elaborates upon a motif introduced in the Caballeros Footbridge, which would span 140 meters, roughly two thirds of the Sundsvall Bridge's longest span. In this evolution one can clearly see the response to the increase in scale. The cable-stayed structure supports the deck by means of two pylons symmetrically suspending the 272-meter central span, rather than the single-pylon scheme of the Caballeros Footbridge, though the shape of the pylons, framing the deck that traverses them, and the way the cables are anchored to the pylons' heads derive from the Caballeros. However, the profile of the pylons and the way the return anchorages are set differ greatly from the earlier project as a result of the shift in scale.

Photomontage.

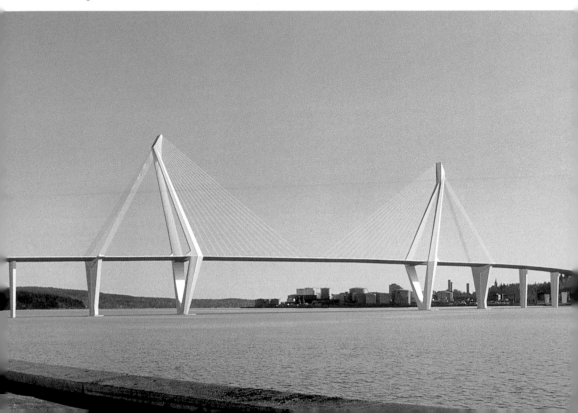

Reuss Footbridge Flüelen-Seedorf, Switzerland, 1989

Returning to a more intimate scale, the Reuss Footbridge is a rural bridge project using the twin arch motif but with both arch and deck constructed out of timber. Here hinged, tied arches made of laminated wood support unbalanced loads without the aid of a stiffening truss or girder at the walkway level. A thin wooden deck of larch rests on cross beams, which are in turn hung by wooden suspenders. A steel tie rod within the deck stabilizes the structure and takes the horizontal thrust of the arch. The arches' formal dominance over material becomes clear when comparing timber construction to the more conventional steel construction, as do the limitations each material poses.

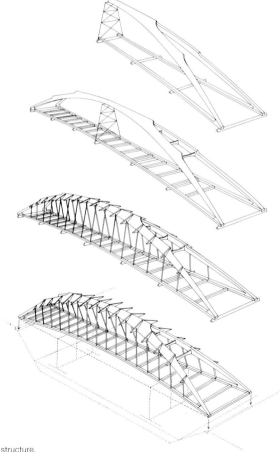

Axonometric drawings showing structure.

Gentil Bridge Paris, France, 1988

Because of their strong bilateralism, and despite the fact that the arches used in both the Oudry-Mesly and Reuss Foot-bridges are inclined, the motif of the tilted structural member is less evident than in the Bach de Roda Bridge, for instance. The motif of the tilted structural member is powerfully displayed, however, in the project for the Gentil Bridge over the Seine in Paris. This bridge, like the Caballeros Footbridge, is a seminal work in Calatrava's oeuvre. The scheme uses an arch inclined at a statically ideal 70-degree angle placed asymmetrically on the side of the road deck, the weight of which counterbalances the arch.

Clearly, the configuration of a bridge deck suspended from an offset steel arch evolved out of the Bach de Roda's inclined arches — the secondary arch that was leaning 60 degrees, joining the main vertical arch at its crown — by removing the main arch and leaving the secondary arch to tilt alone. Like the inclined pylon, the tilted arch is also a compelling motif that will return in later bridges, as well as in building projects. Another characteristic embedded in the motif that evolved from the Bach de Roda's tied arch is the tensile struts that replace the suspension cables to transmit forces from deck to arch.

In the case of the Gentil Bridge design, the arch delivers the various deck loads to springing points adjacent to the abutments at either side of the river. The roadway support structure acts as a horizontal beam between the abutments, delivering loads to the tension arms and developing the necessary component of force required to load the tension arms purely within the plane of the arch. The beam also prevents lateral distortion and acts as a perforated torsion box to resist rotation of the tension arms into a position of equilibrium as a result of the horizontal and vertical forces. In addition, the bridge's tensile arms provide lateral bracing for the arch, preventing buckling. Gravity loading displaces the arch to a more vertical position, slightly stiffening it and providing further protection from buckling.

Above: Section.

Opposite: Model.

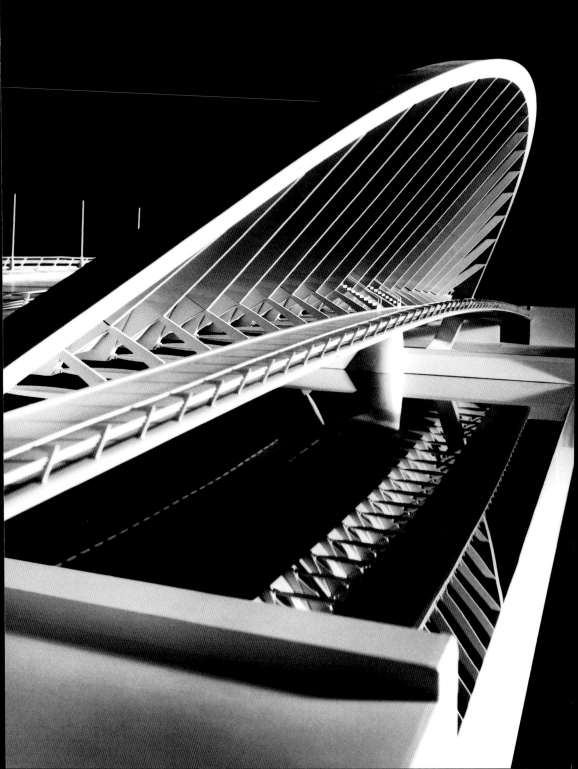

Miraflores Bridge Cordoba, Spain, 1989

While the arch in the Gentil Bridge is piv- asymmetrical cross section, and the road
oted from beneath the deck, the design deck counterbalancing the inclined arch.
for the Miraflores Bridge applies all three With the substitution of cables for tensile
innovations of the Gentil scheme: the struts in the arch, all three are interwoven
arch inclined at a 70-degree angle, the into one motif.

Above: Sketches.
Opposite: Model.

Cascine Footbridge Milan, Italy, 1987

The Cascine Footbridge project, intended to cross the Arno, was designed for the seventeenth Triennale de Milano. Here the side spans and abutments are cast in concrete and support a central arch and suspended deck. The project brief describes the arches as "inclined curves that touch at their highest point to create an elliptical shape, which is repeated in the shape of the suspended steel deck." The arch, which is 10 meters deep, rises to a height of 21 meters above the river. The bridge's total length is 125 meters, and its maximum span is 74 meters at the deck and 104 meters between piers. The deck, its access points, and the arch are fused in a continuous bonelike configuration, the most streamlined of all of Calatrava's bridge schemes.

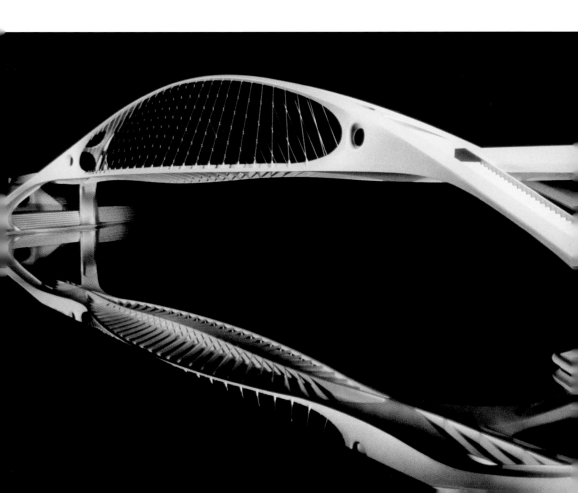

Wettstein Bridge Basel, Switzerland, 1988

The Wettstein Bridge for Basel, designed a year after the Cascine, is a complex, elaborate structure generating a completely different effect. While the structural elements are fused in the Cascine, here they are almost pedantically articulated. Intended for construction on the site of the original Wettstein Bridge, which was built in 1879 and connected the districts of St. Albans Vorstadt and Theodorsgraben at a sharp bend in the Rhine, the project used the existing piers of the old bridge, preserving its original rhythm. The proposed bridge is 27.5 meters wide and has a total length of 199 meters, with a maximum span of 66 meters. The bridge is supported on new steel castings, and steel tension ties run along the top surface of the piers to hold these castings in place laterally, while the piers are lowered to their original height.

The structure of the scheme is ambiguous. The bridge appears to be a steel, rib-stiffened, triple-arch bridge. But because the ribs are structurally integrated with the reinforced-concrete roadbed, they convert the deck and the arched structure into the top and bottom chords of a transparent Veerendel truss — whose inclined sides echo the leaning arch motif, which Calatrava was using at the same time for the Gentil Bridge. This composite action stiffens the bridge and permits the use of lighter members and a shallower arch (only 6 meters deep). The effect of lightness, transparency, and graceful flow is emphasized by the placement of the pedestrian decks two steps higher than the road deck, which includes a lane for bicyclists dynamically cantilevered out from the central road deck. The result is a continuous open space along the full length of either side of the main bridge deck, through which light can play on the substructure beneath.

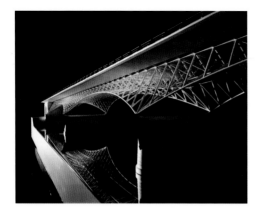

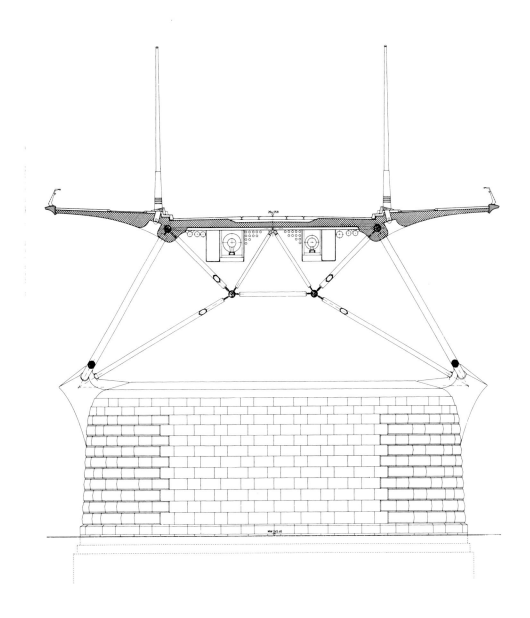

Opposite: Model.

Above: Section.

Médoc Swingbridge Bordeaux, France, 1991

Pedestrian and vehicular flows are separated in the project for the 240-meter-long Médoc Swingbridge. Each is allocated a specialized deck, with the pedestrian paths placed at the outer sides of the bridge. Movement plays a fundamental role in defining the scheme, which is based on a moving deck that turns to let large vessels pass, thus avoiding the construction of a high deck. The figure of the deck suspended by cables radiating from a single tall mast strongly resembles a sailboat.

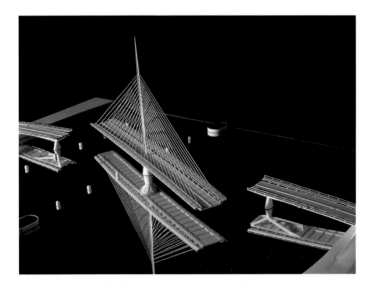

Above and opposite: Model.

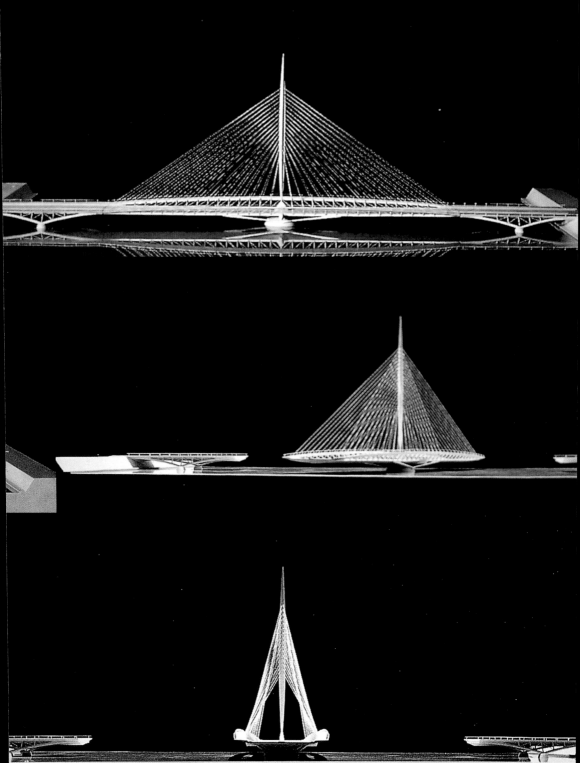

Alamillo Bridge Seville, Spain, 1987–92

No other bridge by Calatrava manifests more powerfully and in a more succinct and lucid manner the leaning pylon motif and the general spirit of the poetics of movement than the Alamillo Bridge in Seville. The scheme can be seen as an abstraction and amplification of the structure of the earlier bridge projects in which the possibilities of the leaning pylon motif were first investigated. Inclined pylons had been used earlier but never devoid of counterstays. The idea can be traced back to earlier sketches for a sculpture in which an inclined stack of marble cubes is balanced by a tensioned wire. The sculpture was later constructed in 1986 with the title *Running Torso*. Perhaps because of the radical and starkly abstract qualities of the Alamillo scheme, no other project of Calatrava's has encapsulated more concisely and more lucidly the ideas of his poetics as this project.

The year 1992 belonged to Spain. The nation celebrated the fifth centenary of Columbus's discovery of the Americas and hosted the Olympic Games in Barcelona and the Universal Expo in Seville, for which Calatrava's Alamillo Bridge became an icon. But the story of the bridge begins earlier, two years after the Caballeros Bridge was designed. In 1987 the Andalusian government commissioned Calatrava to design a bridge on the occasion of Expo '92 as part of a government initiative to provide better road connections to neighboring towns as well as a ring road for Seville and eight new bridges over the Guadalquivir River. Due to severe flooding, the river was redirected to create an artificial island where the facilities for Expo '92 were to be situated.

The bridge, intended to provide access to the north gate of the exposition grounds, consists of a 142-meter-high pylon inclined at an angle of 58 degrees holding the bridge's 200-meter single span over the section of the river known as the Meandro San Jerónimo by means of thirteen pairs of stay cables arranged in a harp pattern. The core of the tower contains a service stair to the top. The bridge deck is made out of a hexagonal steel box beam spine, to which the stay

Opposite: Aerial view.

Following pages: Night view.

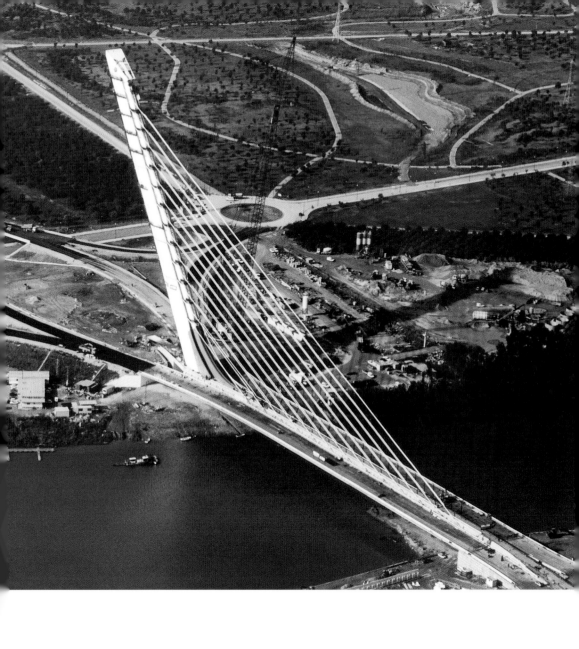

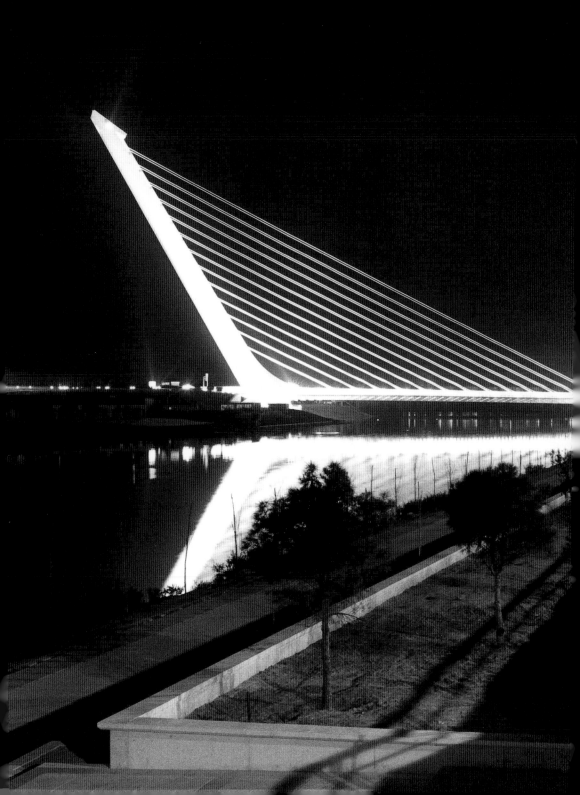

cables are attached. The steel wings supporting the deck to either side are cantilevered off of this spine, whose 3.75-meter-wide top side, elevated some 1.6 meters above road level, serves as an elevated footpath and cycle route between the separated roadways. Each of the road decks has a capacity for three traffic lanes. Between the pedestrian deck, the top of the box beam, and the vehicular deck are openings that allow for natural light to penetrate beneath the bridge, a strategy that also appears in the 9 d'Octubre bridge in Valencia and in the Lusitania Bridge in Merida.

As with his earlier bridge projects Calatrava paid particular attention to the pedestrian's total experience crossing the bridge, at a level above the roadway. When she reaches the 500-meter-long Puente de la Cartuja Viaduct, built at the same time as the bridge, she continues her walking journey down on the cantilevered decks, under the roadway. The two 10-meter dual carriageways cantilever 5 meters away from the top of the structure, providing shade for pedestrians on the promenade decks below. The viaduct's underside takes the form of a vault, with the space

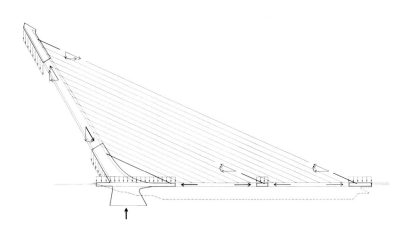

Above: Section indicating forces.

Opposite: Detail showing reinforcement of the pylon's base.

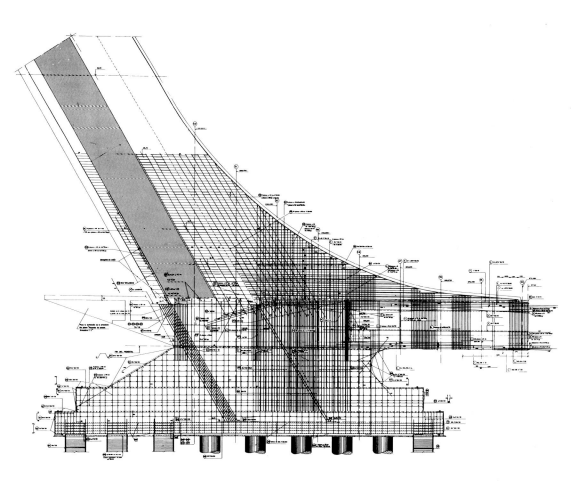

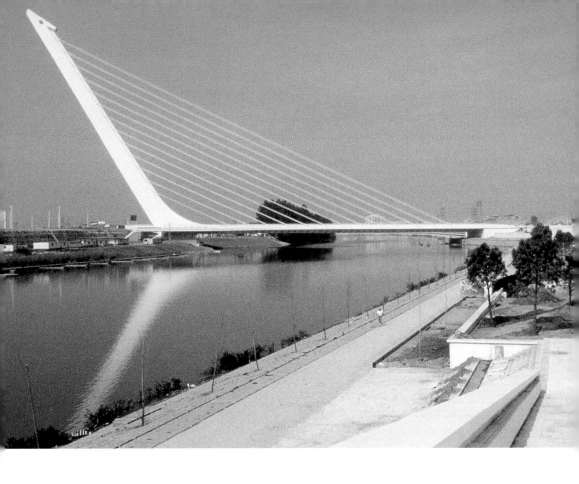

under the structure receiving light through three continuous rows of circular light wells, one along the crown of the vault between the two roadways and the other two at the sides.

The site where the Alamillo Bridge was meant to be built is unusual in the sense that the same river is crossed twice. As a response to this natural constraint and for reasons of symmetry, Calatrava initially proposed two cable-stayed bridges to span the two sections of the river. The mirrored bridges — with their pylons tilted toward each other, approximately 1.5 kilometers apart and connect-ed by the Cartuja Viaduct — would have suggested a huge triangle, its apex high up in the sky. In later stages of the design the second bridge was dropped due to increasing costs. The version that was ultimately built consisted of a single bridge spanning the Meandro de San Jerónimo and incorporating a 350-meter-long park and the 500-meter-long viaduct over the island. The officials responsible for the scheme's execution offered their complete support for the unprecedented and daring concept proposed by Calatra-va, not only for aesthetic reasons but also because Calatrava demostrated that he

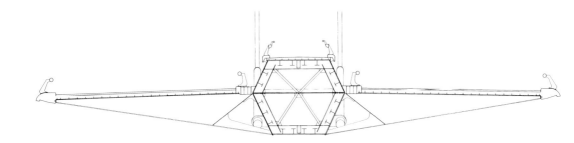

Opposite: General view.

Above: Section showing vehicular and pedestrian decks.

had mastered the construction process necessary to complete the bridge. Given its leaning configuration, this process was not a simple one. Originally Calatrava's plans specified that the box girder and road deck would be hung from the pylon in stages as they were being built, but this proved too daring for the engineering firm hired for the project. Thus, a more traditional building system was adopted: The pylon was constructed by lifting segments of the steel shell into place with a large, high-capacity crane, then welding the segments together and filling them with reinforced concrete.

In the end, while the symmetry of the initial twin bridge scheme and the implied figure of a monumental cosmic triangle were sacrificed, in retrospect the adop-tion of a single-bridge scheme only benefited the project, emphasizing the strangeness and originality of the leaning asymmetrical pylon and its hieratic, almost phallic presence in the landscape. Its stark, simple, and solitary profile made the bridge a memorable landmark and ultimately the trademark of contemporary Seville. Particularly striking is the unprecedented elimination of back stays to support the leaning pylon, with the weight of the deck being sufficient to counterbalance the pylon's forces. The concept for the Alamillo Bridge evolved further in the project for the 1997 Port de Barcelona project, returning to the original twin bridge scheme but transforming the original pyramid formed by the two leaning pylons by splitting and reversing it.

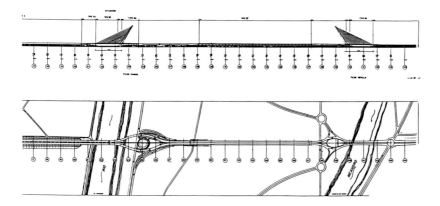

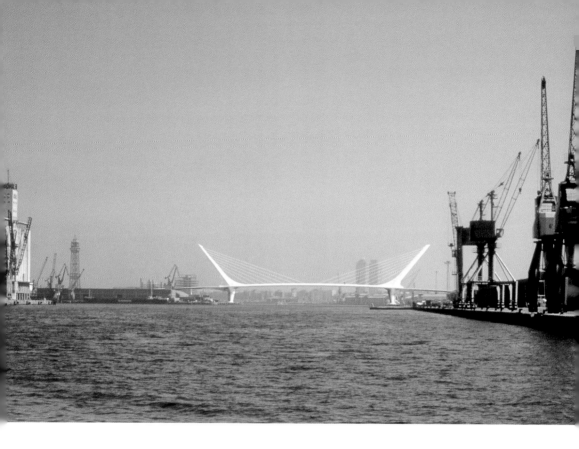

Opposite: Drawing of original proposal.

Above: Photomontage of Port de Barcelona project.

Trinity Footbridge Salford, England, 1993–95

The design for the structure of the Trinity Footbridge is a hybrid form produced by crossing the leaning pylon motif of the Alamillo Bridge with the Médoc Swing-bridge variation. Later, we will discuss the bridge's regenerative role as an urban intervention. Here, we will focus on the innovative aspects of its structure and of the configuration, which emerged to a great extent from the need to adapt to the constraints of the site. Due to the difference in the riverbanks' height, Cala-trava's design incorporates an asymmet-rical, inclined, single-mast cable-stay bridge with two converging curved approach spans that meet at a point from which the pylon soars upward. The main span crossing the river, as well as the approach spans, are suspended from this mast by means of cables, which in

the case of the centrally stayed main span remain in the same curved plane generated by the line of the pylon and that of the deck. The main span from the opposite bank to the pylon is 54 meters. The deck comprises a triangular steel box girder supporting a footpath 4 meters wide. The deck surface is com-posed of clay block paving.

The shape of the leaning pylon is a long sharp nose, an elliptical paraboloid configuration used by Calatrava earlier for the upright pylon of the Collserola Com-munications Tower designed for Barcelona in 1988, the stability of which depended on a system of cables. The pylon is 41 meters long, with a diameter between 550 millimeters and 1.22 meters. While the Médoc Swingbridge pylon is vertical, the pylon here is tilted at an angle

Opposite: View of pylon.

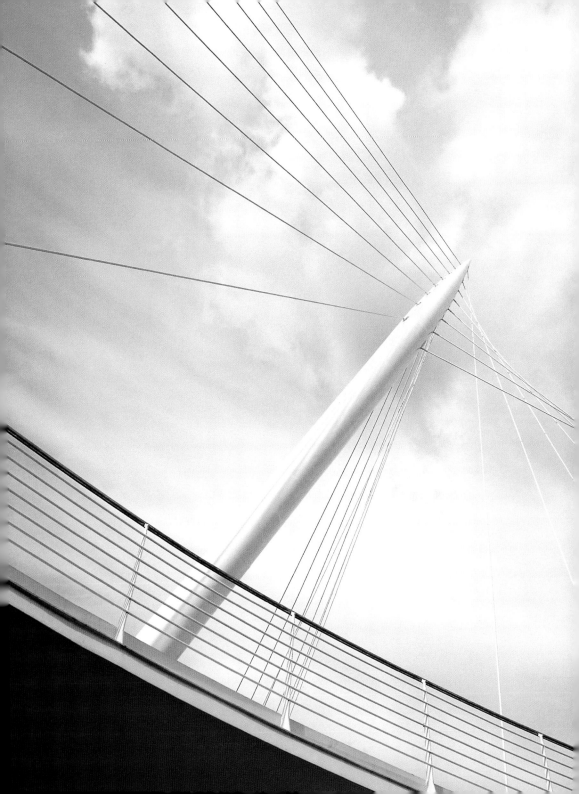

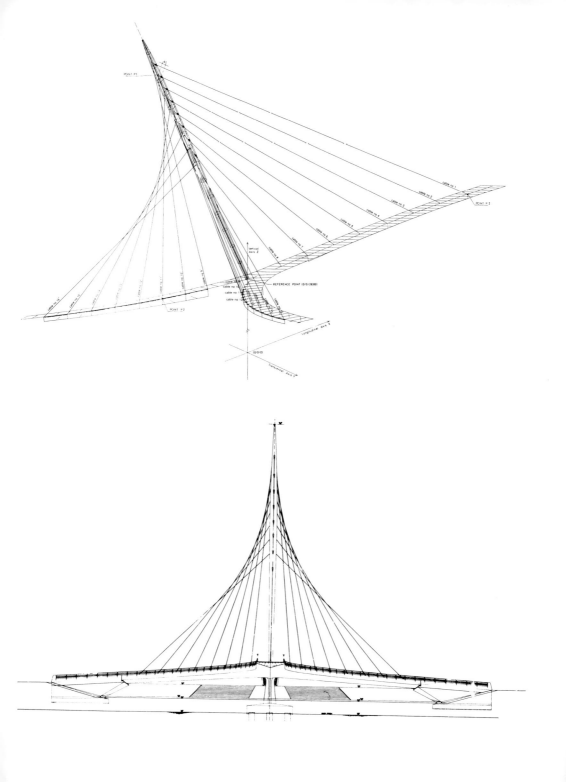

of 60 degrees. In the Médoc bridge and the Collserola tower, load transmission to the ground occurs in the vertical axis of the pylon, with the cables counterbalancing all horizontal forces; in the case of a tilted pylon the forces must follow the direction of the tilted axis, allowing the structure to still be slender at the point where mast and support meet. The three-dimensional array of cables compensates for all forces, guaranteeing that the stresses to the pylon are those forces parallel to its axis. The pylon's thickened midsection provides resistance against buckling.

An unusual feature of the bridge is the way the cables are anchored within apertures in the surface of the pylon. This system called for great accuracy, since the anchor points required welding into the cone sections at precise angles before all sections were joined to form the pylon.

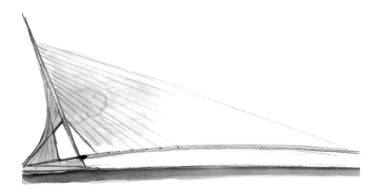

Opposite, top: Drawing showing pylon, cable, and deck system.

Opposite, bottom: Cross section.

Above: Sketch.

Petah Tikva Footbridge Petah Tikva, Israel, 1998–2005

A further permutation of the original cable-stayed steel bridge structure with a leaning pylon occurred in the conception of the scheme for the Petah Tikva Footbridge, near Tel Aviv. The scheme employs once more the motif of the leaning pylon in a variation generated from the need to adapt circulation patterns over the deck of the bridge to the constraints of the position of the circulation pattern of the roads on the ground.

The site of the bridge is Jabotinsky Road, the main east-west artery between the city of Petah Tikva and Tel Aviv. Along one side of this busy road are

a recently built shopping mall and residential development with a park. A pedestrian bridge used to span Jabotinsky Road at this intersection, but the municipality removed it to make way for the proposed construction of bus stops in the road's middle lanes. The new bridge connects the shopping mall and the residential development with each other and with Rabin Memorial Hospital; the scheme also provides for a connection to the proposed bus stops. A single structure, designed without the need for mechanical elements and constructed in such a way that it

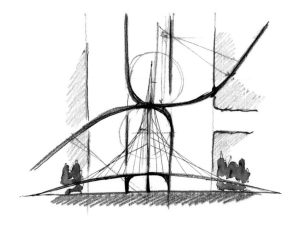

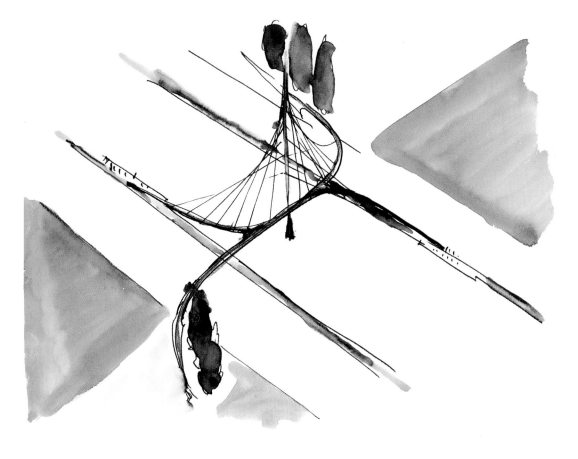

Opposite and above: Diagrams of bridge
and surrounding site.

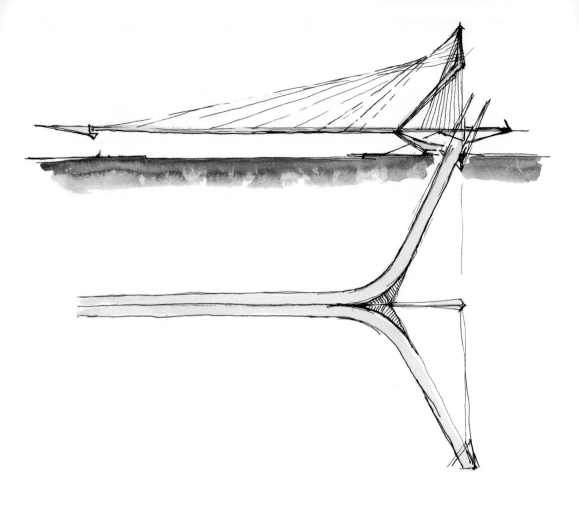

Above: Sketch of plan and elevation.

Opposite: Conceptual sketch.

would not interrupt traffic on Jabotinsky Road, was made possible by giving the bridge the form of a Y-shaped walkway — a straightforward solution.

The span to the hospital across Jabotinsky Road is 50 meters long, while the spans that form the arms of the Y — accessing the shopping mall on one side and the park on the other — are each 39 meters long. The inclined steel pylon, rising to a height of 29 meters, is located at the intersection of the three spans. The pylon features trapezoidal arms and anchors thirteen cables and four counter-cables attached at the deck and the pylon head; the counter-cables are fastened at the pylon head to the pylon arm, and at the pylon arm to the foundation. The lightness of the pylon, the play of cables, and the intersection of paths generate an uncommon place that nevertheless creates a familiar and comforting profile, like a swing suspended from an enormous pole.

Serreria Bridge Valencia, Spain, 1992–

In 1992 the motif of the leaning pylon was adapted once agian in the Serreria Bridge for Valencia, Spain. The bridge is sited along the easternmost edge of Calatrava's City of Arts and Sciences complex, built within the dry bed of the Turia River, and will provide access for automobiles, pedestrians, and public transportation across the riverbed to the south side, where it will connect at a plaza with the El Saler Highway. One of the exploratory schemes for the project adopted the original pylon of the Alamillo Bridge and evolved into a variant drawing from the Pontevedra Bridge scheme. It employs the radial pattern of stays stemming from the head of the pylon and uses backstays. A more innovative version bends Alamillo's original leaning support to form a spiral curve that achieves its maximum radius where it intersects with the deck. The curvature of the pylon follows the requirements of structure's static forces, while the angle was dictated by an analysis of the counterforces against the cable stays. In contrast to the seminal Alamillo Bridge, the scheme uses backstays to improve the pylon's stability. They consist of two groups of paired cables, which are placed in a vertical plane perpendicular to the spine axis, and with a slight angle in the plane. The deck is suspended from the pylon by twenty-nine parallel stay cables at the center of the deck, anchored to the bridge's spine at intervals of 5 meters. It spans 180 meters and varies in total width from 35.5 meters to 39.2 meters. The pylon rises to a height of 118.6 meters. There are three supports: At the northernmost end, where the deck touches grade level, the deck rests on a concrete abutment by means of a pair of bearings that provide resistance to torsion. The second support point is the pylon base, where the steel box spine connects with the pylon, creating a fully fixed connection with the pile-cap by means of a composite steel-concrete box. On the southernmost end, the deck is supported by a pair of

Opposite: Model.

Following pages: Photomontage.

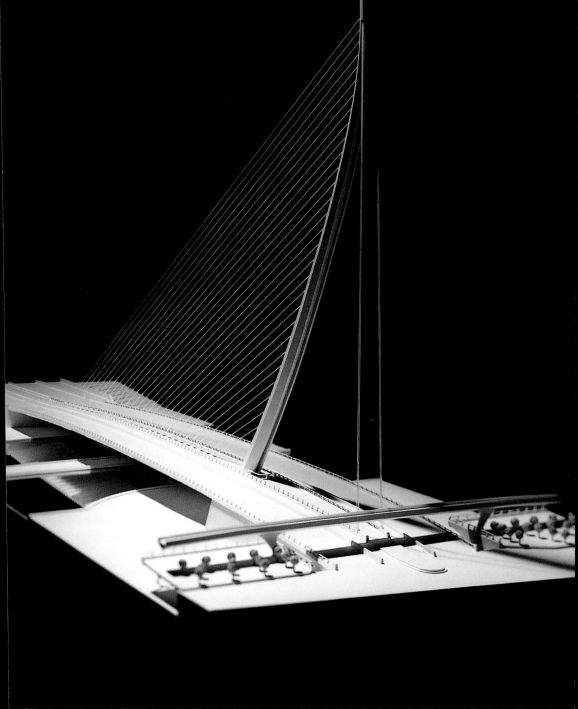

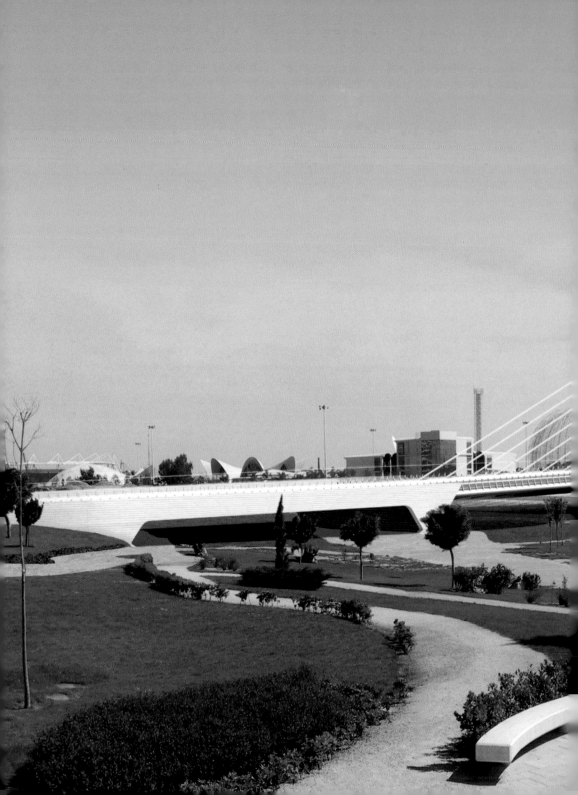

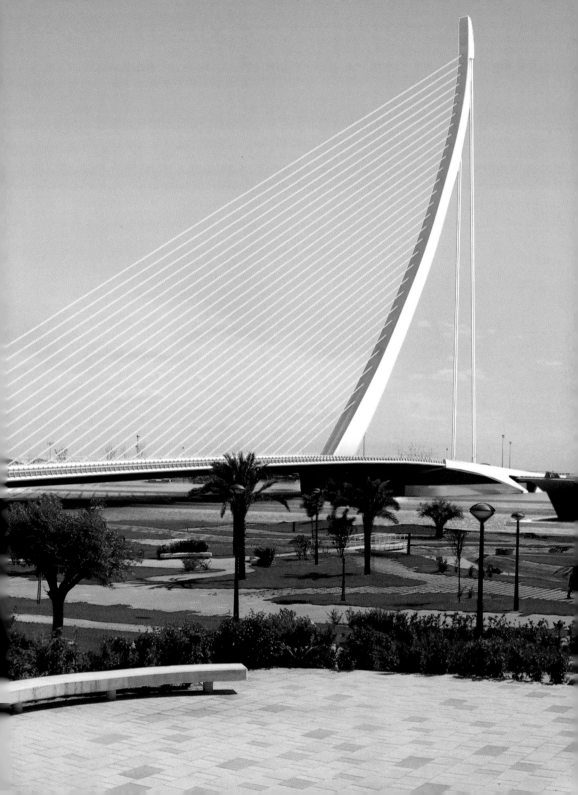

bearings on the abutment. Finally, the backstay cables are anchored to a massive foundation at the southern edge of the bridge to achieve balance.

Once more, the scheme accommodates a multifunctional flow pattern. The deck is comprised of two paved roadways, each 14.7 meters wide. In the center is an elevated pedestrian pathway, which varies in width from 3.7 meters to 7.4 meters and is made with a special asphalt overlay fixed to an orthotropic

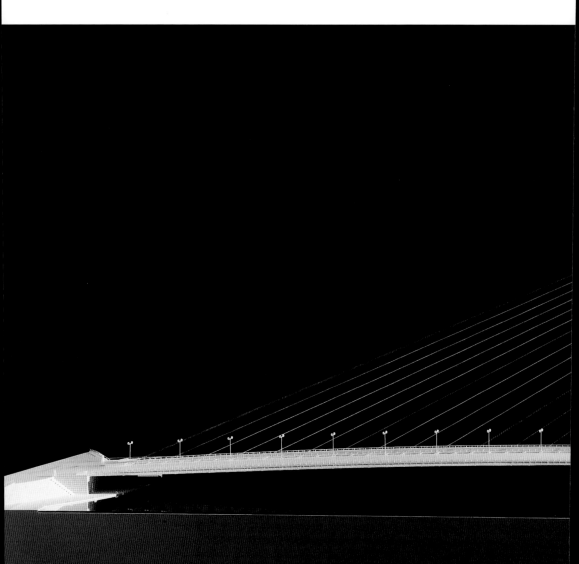

deck supported on cantilevered trans-
verse girders. The pedestrian pathway is
composed of granite tiles. There are a
total of eight lanes of traffic and two lanes
of public transportation (bus or light rail).
Accent lighting is used on the pylon and
cables, and lighting under the bridge
emphasizes the structure's profile and
generates reflections on the water. Light
fixtures are not employed in order to
avoid distracting from the lighting of the
City of Arts and Sciences.

Model of an early version of the Serreria Bridge.

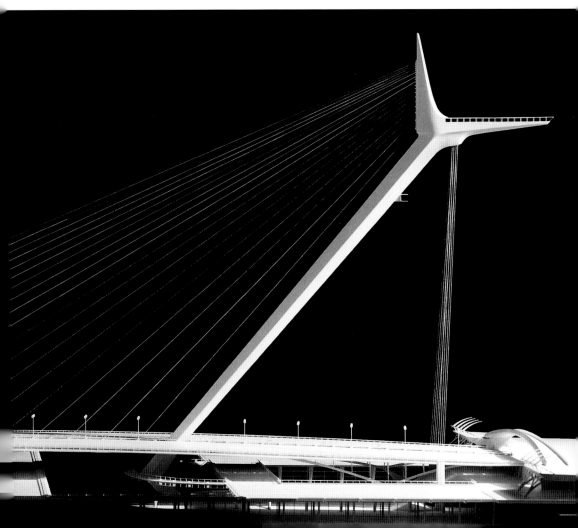

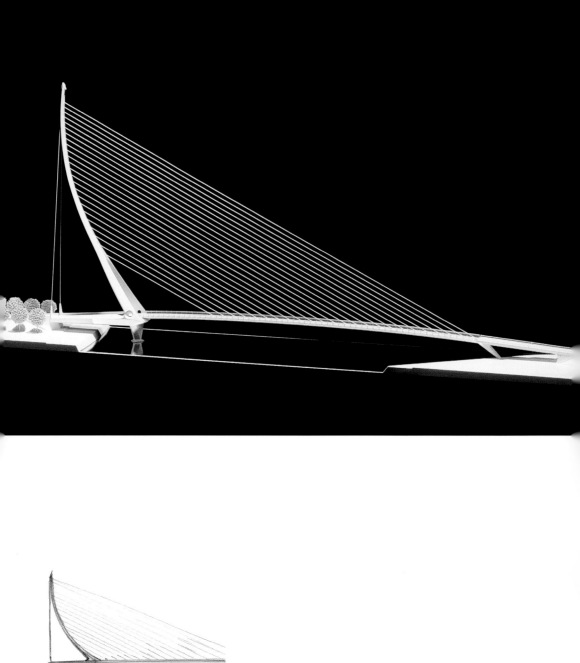

The leaning, curved pylon form was used in later projects, including the 2002 project for the Greenpoint Landing Bridge in New York City and the Katehaki Pedestrian Bridge designed and built between 2001 and 2004 in anticipation of the 2004 Athens Olympics. The dominant Calatrava motif might be seen as an oxymoron, a static structure representing dynamic movement, a pylon or arch leaning on the brink either of falling or rising completely upright, suspended with the help of backstays or the counterbalancing weight of the deck and arrested at the "critical point." The structure is falling but does not collapse; it is rising but does not achieve its full height. The result is unity through paradox.

Calatrava appears to enjoy exploiting like an acrobat this critical point, the state in engineering beyond which, if a certain variable in design is exceeded, the interatomic bonds of a structure will be broken and the structure will fly in all directions at once. This impulse is joined with the "pregnant moment" in aesthetics, at which the structure seems to represent all past and possible future states of the object. There is movement in the structure that seems to resemble the unfolding of the design process, the discovery that follows the stream of options elicited by the search for alternative solutions, followed finally by the optimal answer, so that wonder becomes wonder no more. But still the nascent answer that follows the enigma invites a sense of wonder that never seems to fade.

Opposite, top: Model of Greenpoint Landing Bridge, New York City.

Opposite, bottom: Sketch of bridge with curved pylon.

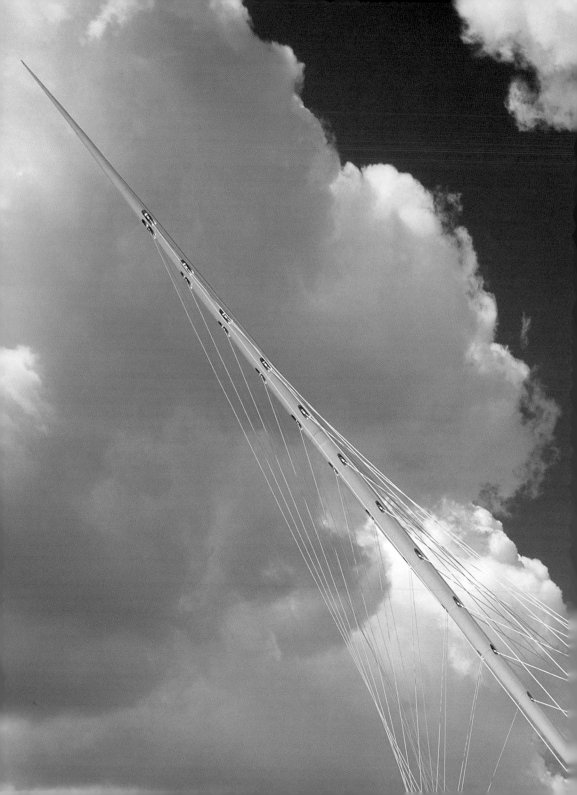

3 Bridges in the Natural Landscape

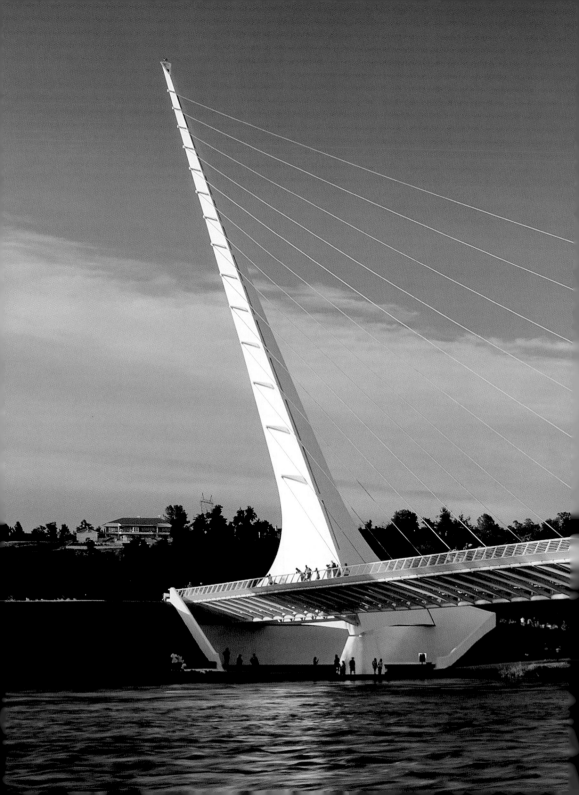

3 Bridges in the Natural Landscape

The concept that the introduction of large-scale infrastructure projects to the landscape is an expression of ongoing "warfare against nature," to quote Lewis Mumford's *The Golden Day*, is not recent. Even in the United States, a country already dependent on industry by the time *Walden* and *The Education of Henry Adams* were written, Mumford noted, the machine was seen to "represent the forces working against the dream of pastoral fulfillment," disruptive, dull, and reductively utilitarian.

Humphry Repton, the great nineteenth-century British landscape architect and theorist, recommended that "offensive" objects "injuring the prospect" be hidden among trees and bushes. His recommendation is still followed today in relation to large-scale, technologally ambitious projects intruding into natural environments. Unless a designer is confrontationally and polemically pro-technology, as designers of the so called high-tech style are, the common attitude is to try simply to hide technology-driven projects underground, camouflaging them with green, or minimizing their profile. By contrast, the Alamillo Bridge, as we have already seen, was given a prominent upright figure, erected in the middle of the serene Guadalquivir landscape. Indeed, Calatrava's bridges in the landscape are anti-picturesque, intentionally conspicuous, and in full view. A similar approach was taken by Robert Maillart when he designed his bridges within the sublime settings of the Alps.

Opposite: Sundial Bridge, Redding, California.

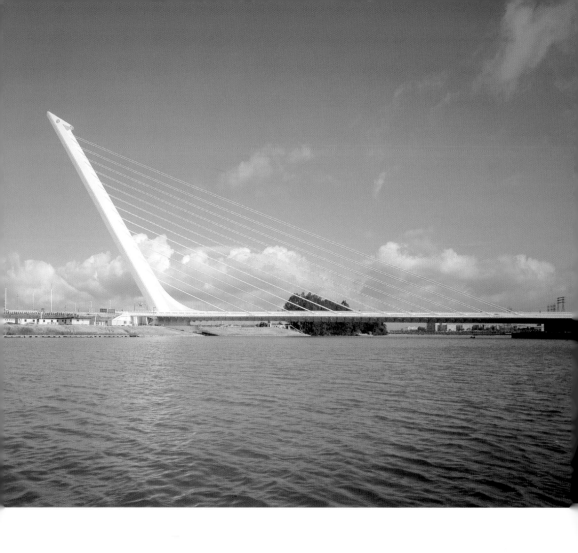

Alamillo Bridge, Seville, Spain.

As much as Calatrava's bridges appear to be clearly distinguished in the landscape, they are not ostentatious or exhibitionistic, and do not antagonistically flaunt their "high-tech-ness" as a fetish. One might say that Calatrava's infrastructure projects, despite the absence of any classical motif in their configuration, have something very classical about them as they stand in relation to nature. They emerge like the pristine and precise volumes of classical buildings in the midst of the meadows, valleys, and soft hills of Attica or Sicily. We may call this approach "strange-making," one of the dimensions of Calatrava's poetics that goes hand in hand with that of the pregnant moment. Such an approach works by making people aware of the world within which they are embedded, inducing them to step out of it and look at it as if just awakened, as if seeing it for the first time. The effect is therapeutic. Like the enigma of the pregnant moment, the paradox of strange-making invites wonder, reconceptualizing one's view of the world and position within nature. Like the pregnant moment, strange-making brings about a shock and with it a sense of possibility, even a yearning to remake one's life.

Lusitania Bridge Mérida, Spain, 1988–91

The Lusitania Bridge was commissioned in 1988 to connect the old town of Mérida in west-central Spain to the newly developed area of Poligono on the northern side of the Guadiana River. The main objective was to accommodate a sharp increase in regional traffic, which followed the naming of Mérida as the capital of the district of Extremadura. The site is exceptional due to its historical significance and the severe beauty of the well-defined contours of the surrounding landscape, toughened by the dryness of the soil and boosted by the splendid Spanish sun.

The main load-bearing element of Calatrava's bridge is a continuous box girder: a torque tube 4.45 meters deep, constructed from post-tensioned, precast-concrete elements supporting the loads of the dual roadway along each of its sides. Prestressed concrete wings supporting the road decks cantilever from the concrete box girder and are post-tensioned to it, strengthening the leaping effect of the arch. Calatrava designed the bridge arch to rise and turn back to the ground with lightness in contrast to the flat stillness of the open land that surrounds it — in other words, giving to the scheme a configuration that appeared strange to the character of the surrounding landscape. At the same time, he gave it a curve that has a deep affinity with the gentle meandering sweep of the riverbed and the smooth shape of the hills on the distant horizon.

Opposite: View with urban context in background.

Following pages: General view.

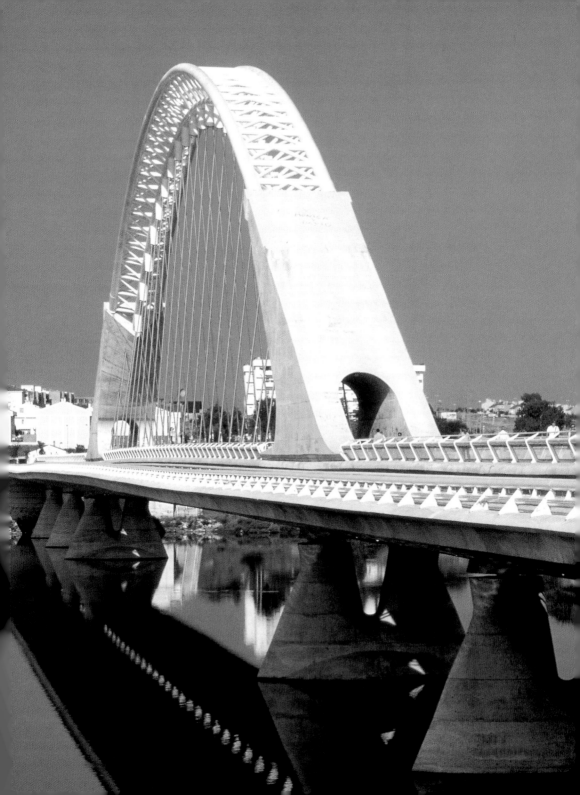

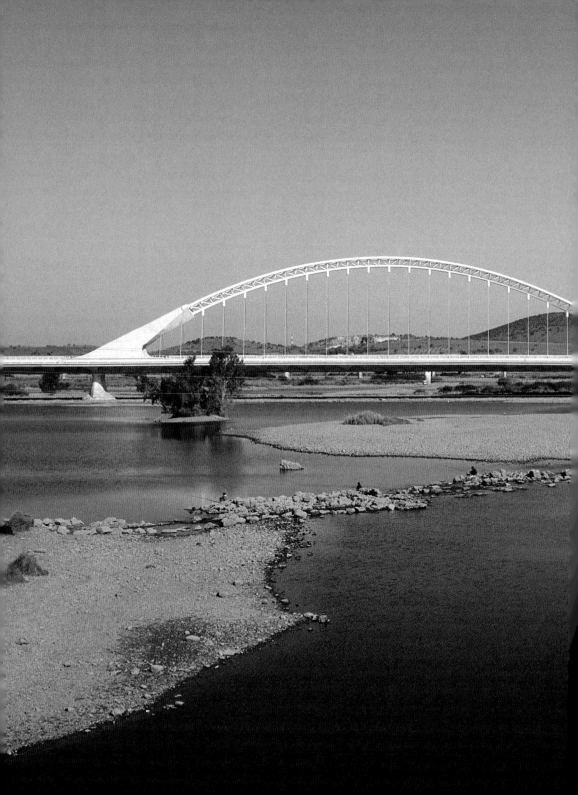

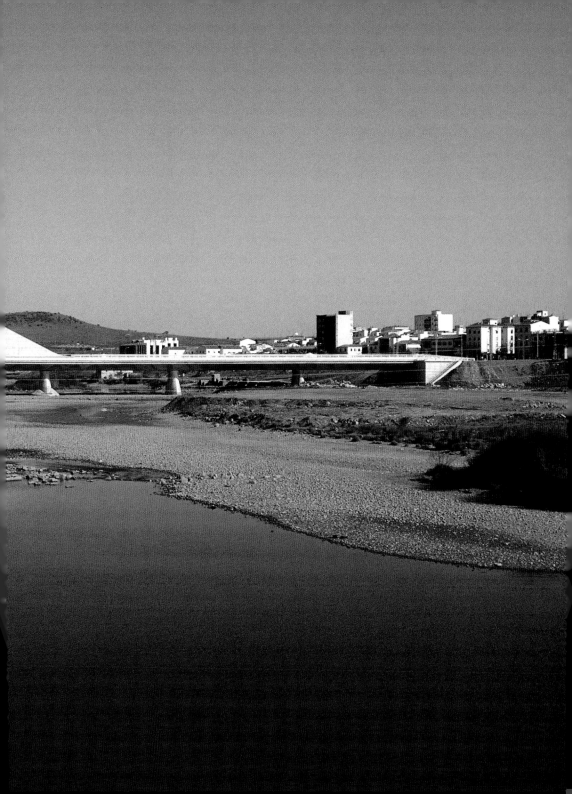

After the initial astonishment of this strangeness comes the recognition that, despite its striking configuration, the bridge is very much in tune with the landscape: Its structure resonates in sympathy with but not imitation of the mysterious power and motion of the natural formations, echoing the concepts Ruskin employed in his study of the Alps, where he saw not a prototype of shapes to be imitated but a paradigm, a concrete representation of the principle of "true" form emerging out of movement, which he hoped designers would follow. Similarly, the affinity between the forms of the hills of Extremadura and the arch of the bridge over the Guadiana River demonstrates the alliance between object and nature.

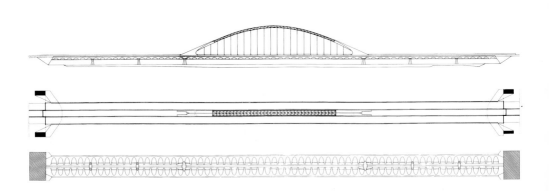

Above: Elevation, plan, and drawing of structure under deck.

Opposite: Cross section.

Following pages: Model.

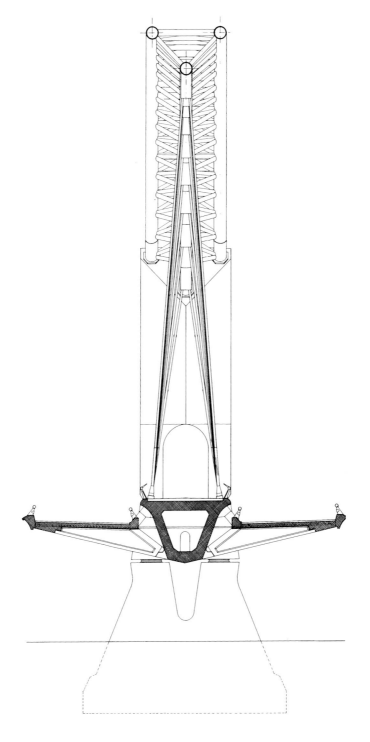

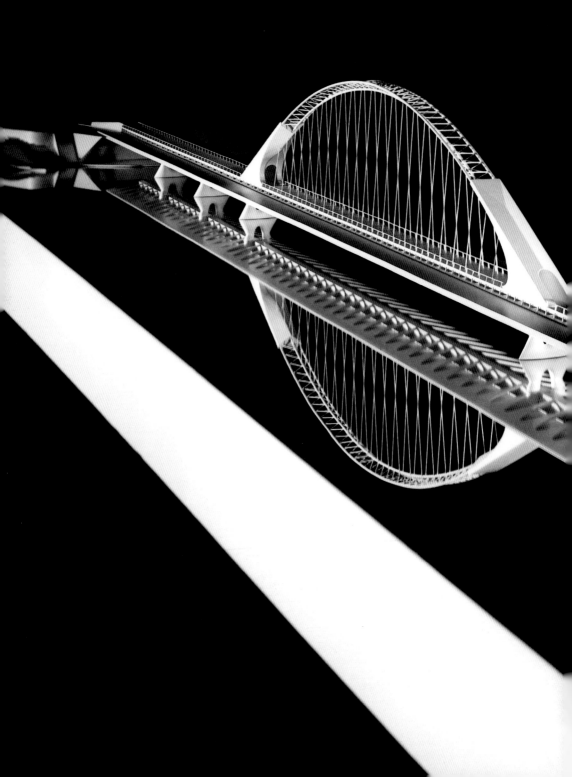

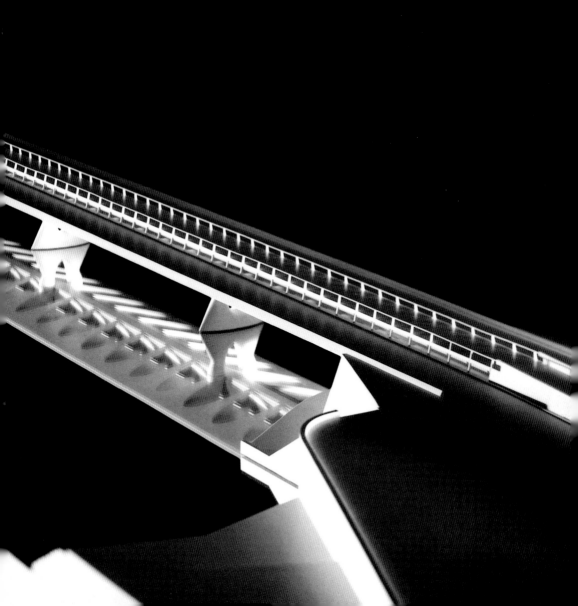

La Devesa Footbridge Ripoll, Spain, 1989–91

The same concepts generating Calatrava's design for the Lusitania Bridge were employed in La Devesa Footbridge in Ripoll and the Puerto Bridge in Ondarroa. Succeeding the design of the Gentil and Miraflores Bridges, La Devesa and Puerto are the first built examples in which the motif of a suspending arch with an asymmetrical cross section was applied. Although both bridges share the same scheme motif, as structures they operate differently.

La Devesa Bridge exploits the transmission of loads in the inclined plane. Its canted steel arch spanning 44 meters carries the loads of the walkway from the existing retaining wall across to a new concrete pylon — a total distance of 65 meters. As with the Gentil Bridge project for Paris, steel tension arms lying within the plane of the arch absorb the walkway loads. These arms are set at an angle of 65 degrees so that their tensioning includes both horizontal and vertical components. While the vertical component stems from the dead and live loads, the horizontal component is developed by a cross truss, which lies directly beneath the walkway and prevents it from distorting laterally. Because the weight of the timber-surfaced deck is not centered beneath the arch, it will tend to rotate, together with the tension arms, into a position of equilibrium below the arch. This rotation is prevented by the torque of the tubular steel spine of the bridge, which collects torsion at each strut and delivers it to the springing points: the pylon and the retaining wall. The tension arms brace the plane of the arch, and as gravity loads tend to deflect both walkway and tension arms, the arch is displaced to a more vertical position, slightly stiffening it and protecting it against buckling.

Above: Plan.

Opposite: View toward raised bank.

Following pages: View from riverbed.

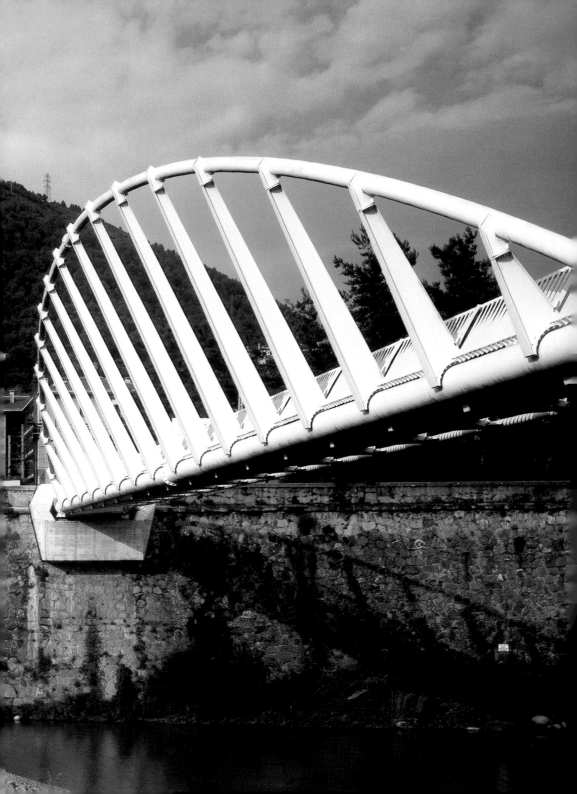

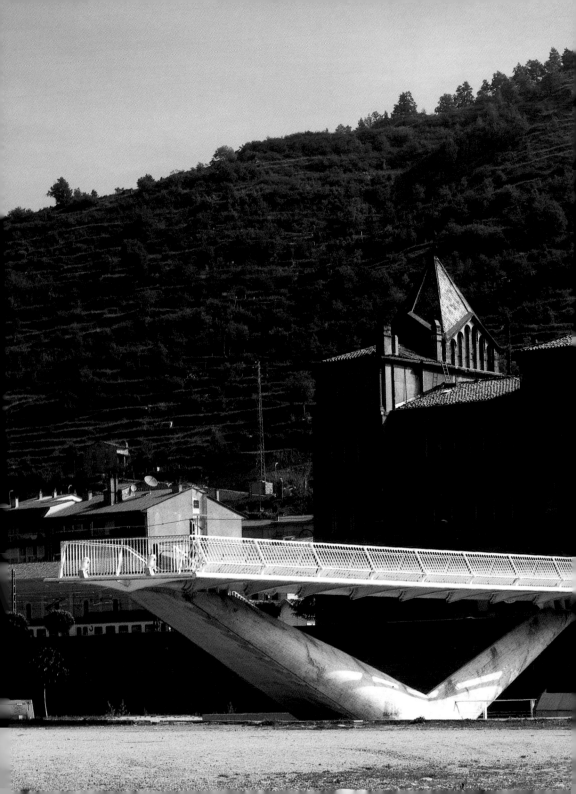

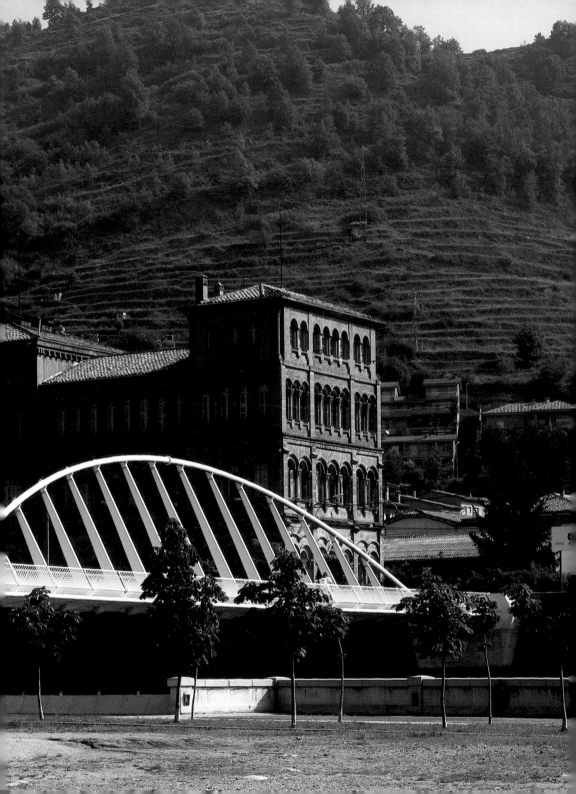

The scheme of La Devesa accentuates the features of its site. As in the Lusitania Bridge, a dialogue is established involving confrontation and agreement between the structure of the object and its surroundings: this occurs through the slope of the bow of the canted arch, 6.5 meters deep, the inclination of the diagonals of the pylons, the stairway projected into the side of the bridge proper. Similarly, the bridge's materials, concrete and wood, are integrated with the colors of the local landscape, while the white painted steel stands out against the backdrop of the Pyrenees.

From the drained riverbed one experiences the massiveness of the concrete pylons together with the lightness of the cross truss's white steel structure against the warm wooden deck — the combination of steel and wood recalling the architecture of early railway constructions — to reach a springboard-like platform that offers a panoramic view.

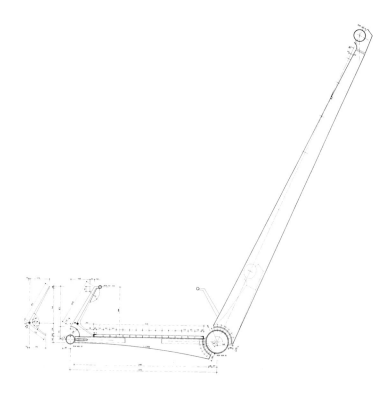

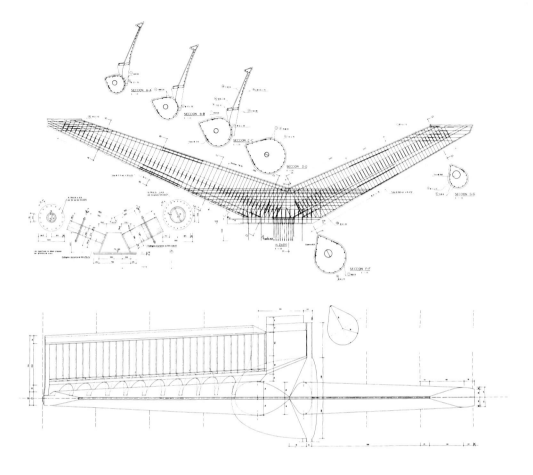

Opposite: Section showing deck
and structure.

Above: Construction detail of
pylon with stairs.

Puerto Bridge Ondarroa, Spain, 1989–91

In contrast to La Devesa Footbridge, the asymmetrical arch and suspension cables of the Puerto Bridge conform to a vertical plane. Only the stiffeners are inclined to define the three-dimensional curve of the pedestrian deck. The 15-meter-deep arch separates the box girder of the roadway deck from the curved, cantilevered pedestrian deck. The consistent width of the steel arch and suspension cables define the southern edge of the road deck on the landward side, while steel stiffeners project from the seaward side of the curved pedestrian deck, reaching up to the thrust of the arch. While the arch absorbs vertical loads from the stay-cables, it is braced against buckling by the inclined tension arms loaded by the sheer weight of the seaside pedestrian walkway. The overall minimum width of the deck area is 20.91 meters, reaching 23.7 meters at its midpoint. The pedestrian walkway, 4.5 meters wide, projects almost 3 meters toward the sea, counterbalancing the weight of the opposite side of the bridge at the midpoint. The bridge relieves the town of Ondarroa of heavy harbor traffic and carries a new approach road 71.5 meters over Artibay Sound to the port.

Both the Puerto and La Devesa bridges share a subtle but profound relationship to their surroundings, emphasizing the unique qualities of their sites and thereby defining their own identities. In the case of the Puerto Bridge, the structure snugly fits into the port of Ondarroa. At the scale of the city, the bridge's curves reflect the harbor and the anchored boats; at an even greater scale it reflects the gentle curves of the surrounding hills. The space between the roadway and the projecting pedestrian walkway allows for natural light to reach the surface of the water below and enhances the "transparency" of the structure both vertically and horizontally. The permeating light trims down the structure's bulk, giving it the delicate filigree of a fishbone pattern.

Cross section showing the two decks.

Opposite: General view.

Following pages: View of bridge in landscape.

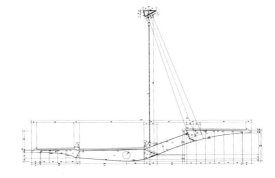

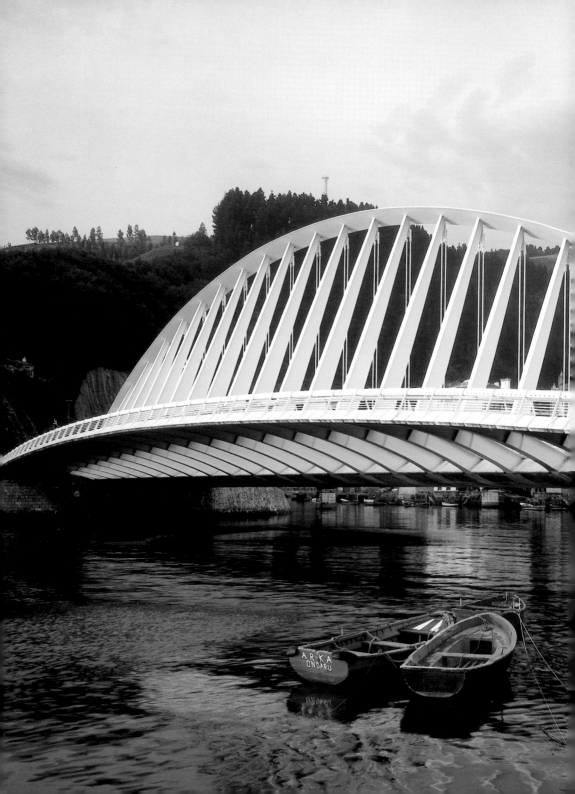

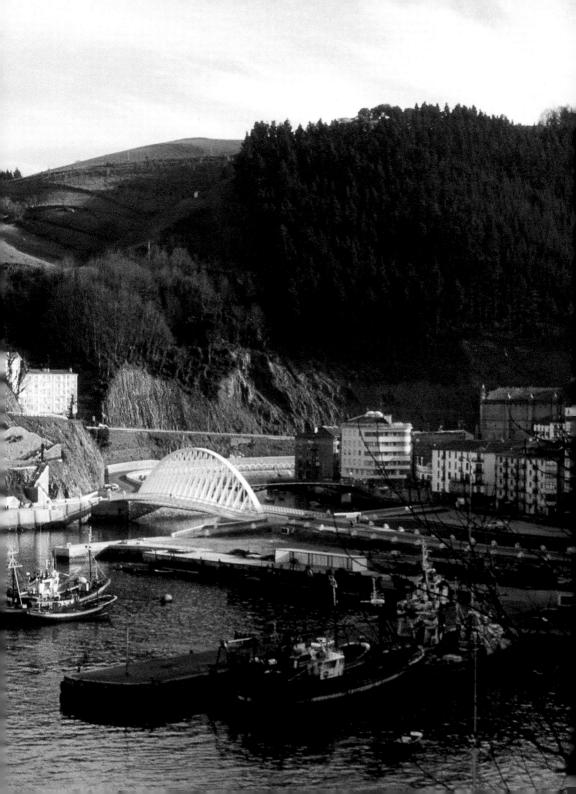

New Bridge over the Vecchio Corsica, France, 1990

In the previously discussed East London River Crossing project, Calatrava created a truss with a curved top-chord supported by the two cantilevered approach spans on concrete pylons. The rising curve of the structure's slender steel arch and the horizontality of the long slim deck compose a laconic but effective scheme within the landscape of the Thames, with the curve of the arch foregrounding the flatness of the landscape while the extended deck enhances it. And though different in configuration and type of structure, the Médoc Swingbridge is similar in intention

and effect, emphasizing the solemn horizon by way of the striking figure of the single tall, immobile mast from which the long, extremely low mobile deck is suspended by tense radial cables. A similar approach was taken in the competition entry for the New Bridge over the Vecchio. With a maximum span of 65 meters, the bridge is composed of a smooth, curved concrete structure rising 23 meters above the riverbed and 5 meters above the support foundation, a form that contrasts with the ruggedness of the mountain landscape within which it is embedded.

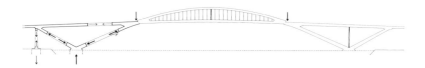

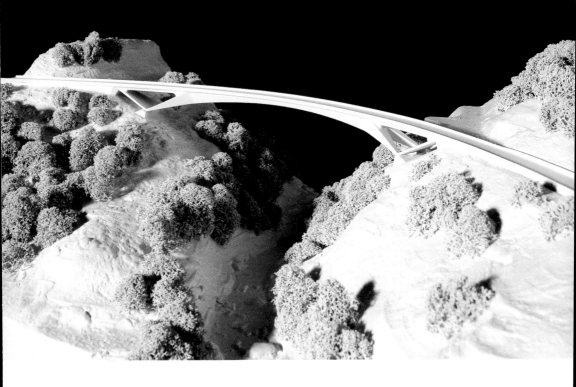

Opposite, top: Médoc Swingbridge, Bordeaux, France.

Opposite, bottom: East London River Crossing, elevation.

Above: Model.

Sundial Bridge Redding, California, 1996–2004

In contrast to the spectacular settings of many of the previously discussed bridges, especially the East London River Crossing and the Médoc Swingbridge, the site of the Sundial Bridge on the Sacramento River in northern California, linking the Turtle Bay Exploration Park's museum building to its 200-acre arboretum, is relatively intimate in scale and ecologically delicate. The park contains a 300-acre campus centered on the Turtle Bay Museum, which features interactive exhibits exploring the relationship between humans and the natural world, as well as trails, wildlife exhibits, a butterfly house, and an amphitheater. The arboretum was developed on land reclaimed from a gravel quarry, at which point the river is a spawning ground for salmon.

The program specified a bridge that would not disturb the natural habitat while also giving visitors access to the river trail system. Calatrava responded with a 700-foot-long bridge scheme — his first in the United States — that spans the river without columns so as not to disturb the salmon population, even going so far as to make the bridge translucent in order not to cast a shadow on the spawning pond below. The bridge is a cable-stayed structure, with an inclined, 217-foot-high pylon built on the north bank of the river. The deck is made of nonskid glass panels set in a steel framework with granite details. The bridge's structure is stabilized by a steel truss and is exceptionally light, weighing only 1,600 tons (the Golden Gate Bridge weighs 419,800 tons).

Opposite: View of bridge in landscape.

Following pages: Night view.

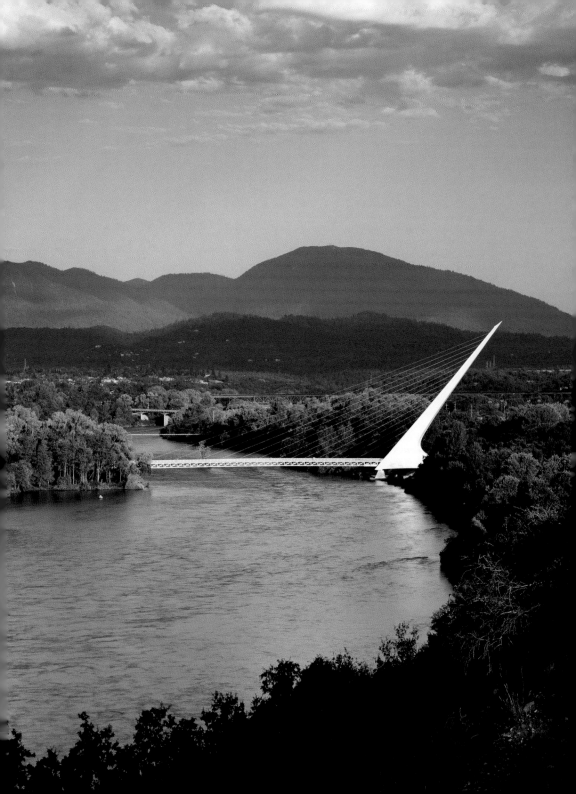

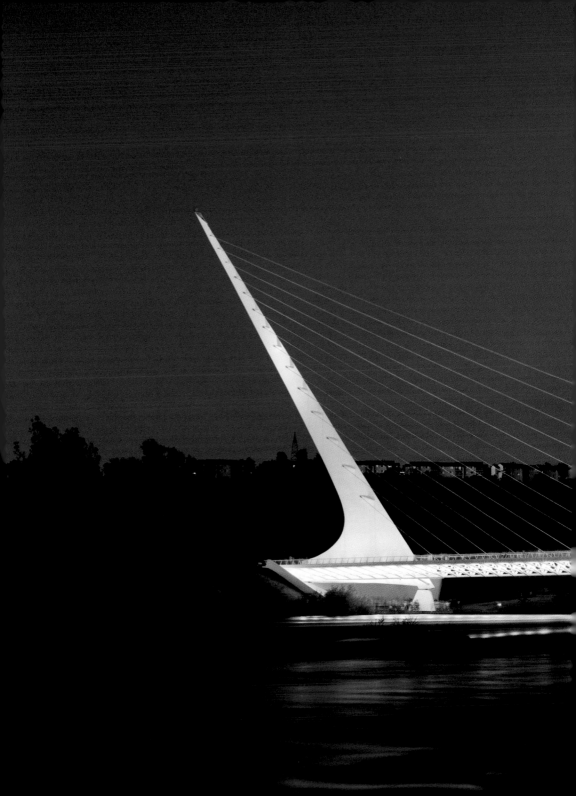

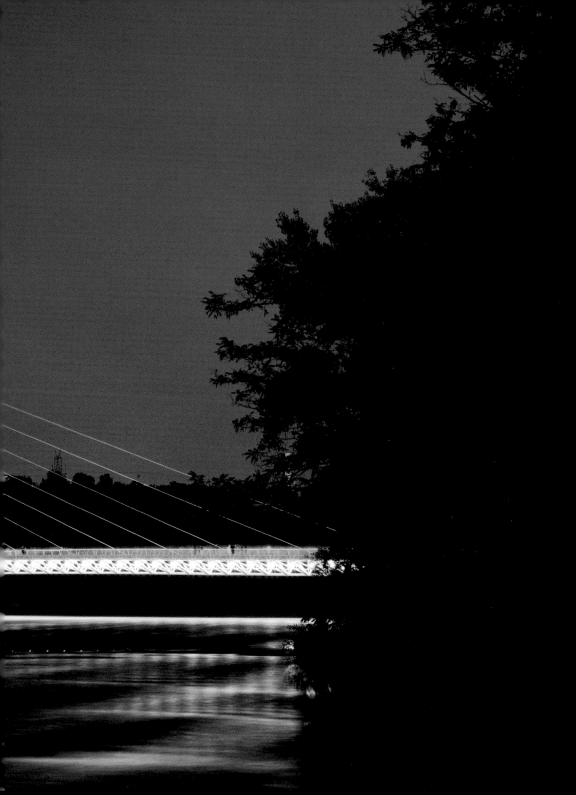

The bridge's exact north-south orientation transforms the pylon into a sundial's gnomon. Developing this theme, Calatrava made the pylon hollow, so that visitors to the base — at river level — can look up through it, and slots in the pylon align with the noon sun, illuminating the interior. Someone standing beneath the pylon at this time can look skyward and see a spectacular sight as well as the afternoon sky. To encourage visitors to linger at this spot and enjoy the river, Calatrava extended the base of the pylon with a sloping platform, formed like a small amphitheater, with walls clad in irregular ceramic tiles. Thus, visitors engage the world that surrounds them on several scales, ranging from the intimate to the cosmic.

Above: Site plan.

Opposite: View toward pylon.

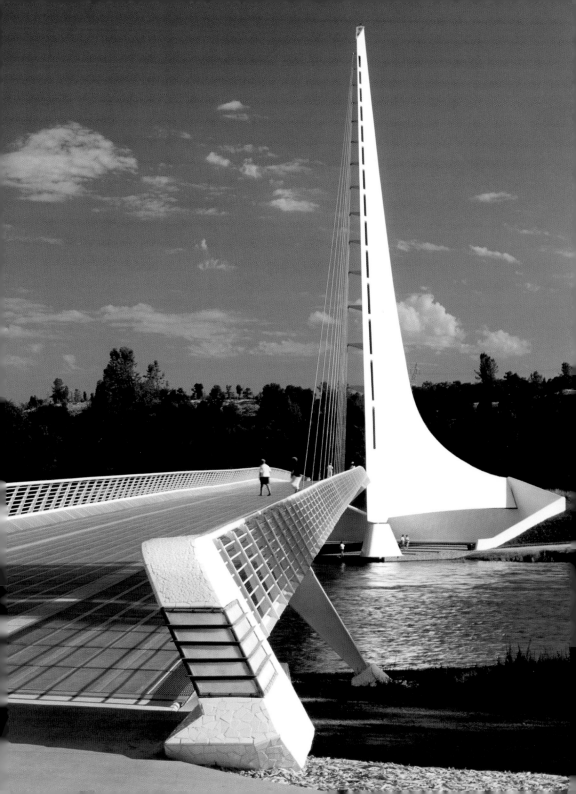

Mimico Creek Bridge Toronto, Canada, 1996–98

Like the Sundial Bridge, the Mimico Creek Bridge is a relatively modest project explicitly intended to enhance its site. The project is part of an extension of the waterfront trail along Lake Ontario, on the west side of the city. The site is not far from the much larger Humber River Arch Bridge, which some observers have called the most beautiful bridge in Canada. The scheme employs a single inclined arch resembling the canted arch projects discussed earlier, with the path of the structural forces through the curved arch echoing that of the water moving through the bending stream that passes under the bridge.

The bridge is designed for pedestrians and bicyclists and spans 44 meters, with a 2.5-meter-wide deck. The main elements of the steel superstructure are a 600-millimeter-diameter torsion tube, a 200-millimeter-diameter edge tube, and a 200-millimeter-diameter arch tube. These structural steel elements are connected by means of floor beams, bracing members, and struts using a combination of welded and bolted connections. The exceptionally light superstructure, which weighs only 50 tons, was designed to be prefabricated offsite as four pieces and then assembled into a single unit on shore, after which it was lowered into place by a crane. The bridge foundations include steel tube piles socketed into the underlying bedrock at the side.

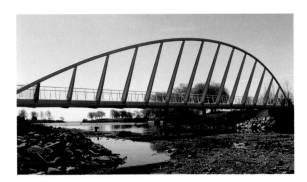

Above: View of bridge in landscape.

Opposite: Detail of struts.

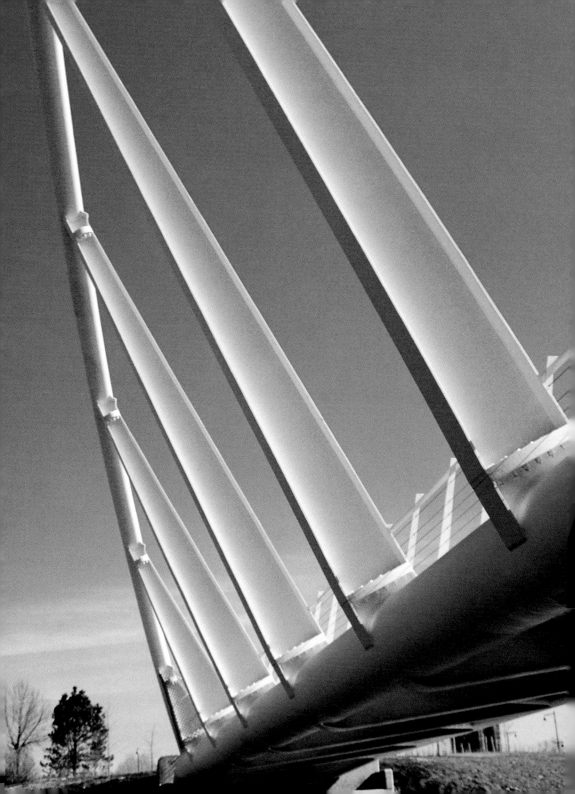

Pont de l'Europe/Pont d'Orléans Orléans, France, 1996–2000

On a different scale, the issue of the environmental impact of pylons on the riverbed of the Loire played an important role in determining the scheme of the Pont de l'Europe. Here the concern was that the project would cause instability in the soil and damage the natural flow of the riverbed. The project was commissioned by the consortium of local communities of the region of Orléans to link the communities of Saint-Jean de la Ruelle to the north and Saint-Pryvé Saint-Mesmin to the south. The steel bridge structure employs a suspended inclined arch standing on clear concrete pylons. The steel deck is composed of three sections: 88.2 meters, 201.6 meters, and 88.2 meters long, for a total length of 378 meters. The main section is suspended from the decentralized inclined arch by means of a double series of twenty-eight hangers. With the buttresses at the lower embankment of the Loire, which are made of prestressed clear concrete, the bridge has an overall length of 470.6 meters. The transverse section of the deck is raised slightly to offer a view of the city and the Loire embankments.

The legs of the concrete pylons emerge out of the riverbed to resemble the trees that characterize the Loire riverscape, with the inclined arch seeming to have grown in accordance with the natural principles that govern the vegetation of the site. But, as in previous projects, the striking formal directness of the deck and the geometric buoyancy of the arch and pylons awaken a profound awareness of the potent but delicate identity of the celebrated Loire region.

Opposite and following pages: Pont de l'Europe/ Pont d'Orléans in the landscape.

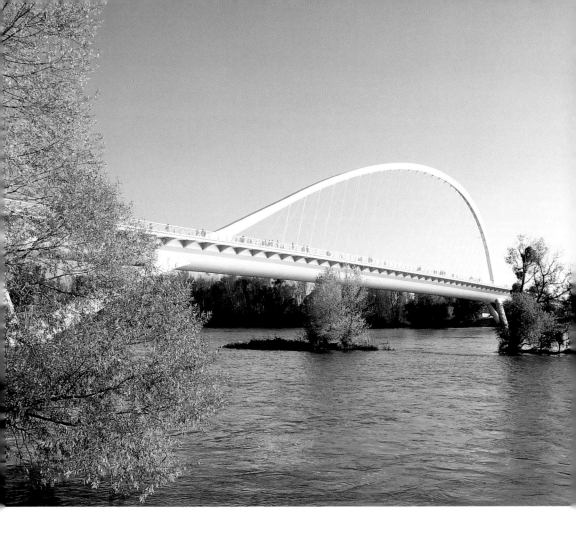

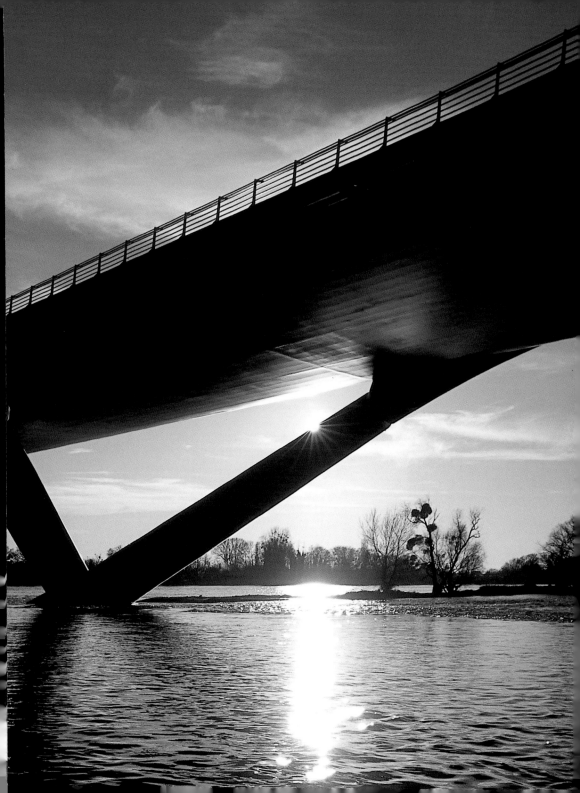

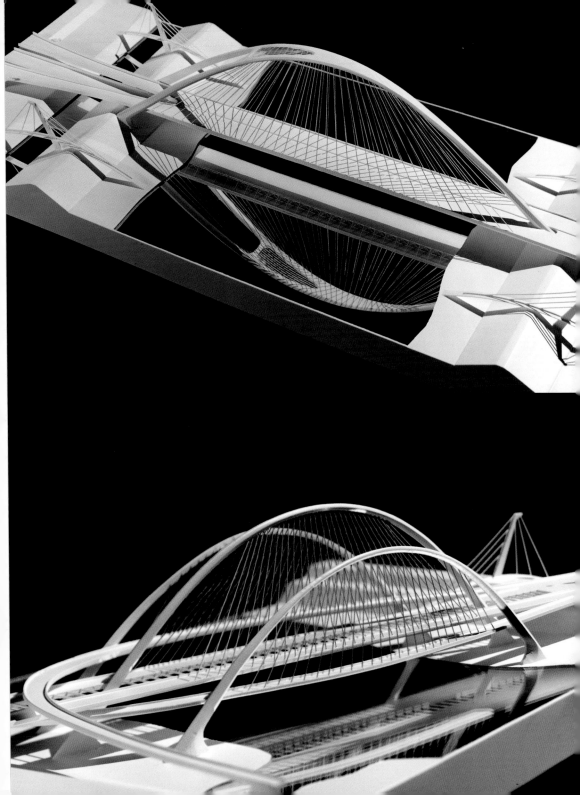

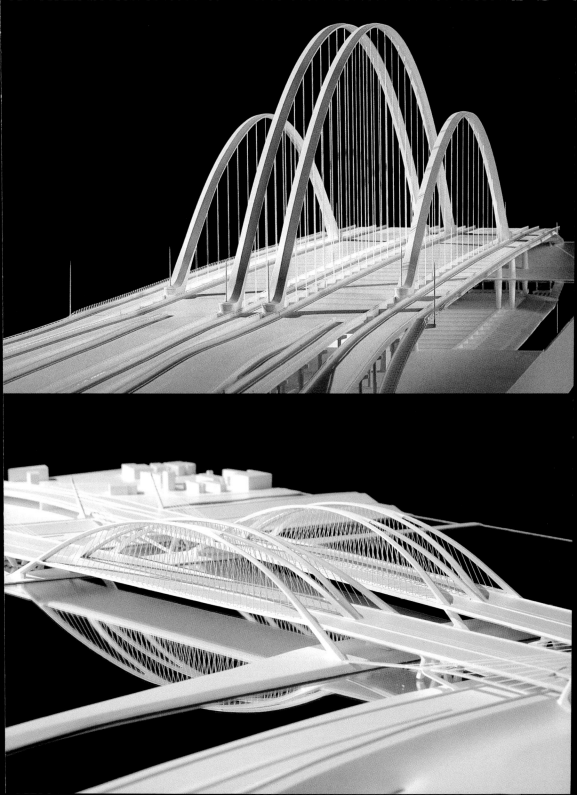

Bridges over the Hoofdvaart Hoofddorp, Netherlands, 1999–2004

A similar set of issues concerning the use of bridges as landscape markers was faced by Calatrava when he was asked to design a group of three bridges over the Hoofdvaart canal. The bridges were constructed on polderland, or land reclaimed from the sea that stands below sea level and is protected by dikes. This is a typical characteristic of many parts of the Dutch landscape where the sea was drained and the area was claimed for agriculture. But today many such areas in the Netherlands are seeing use of the land shifting from agriculture to accommodate housing, leisure, or business.

Located immediately to the west of Amsterdam's busy Schiphol Airport, the municipality of Haarlemmermeer is an area of rapid economic and urban development, centered in the town of Hoofddorp. As part of its infrastructure planning, the regional government resolved to create bridges that would not only serve transportation needs but also function as landmarks at main crossings over the Hoofdvaart to reflect the economic and social changes affecting the region. The program resembled that of the Trinity River Bridges. Following the same approach, the three bridges were designed to be read both as individual markers identifying their particular locations and as an ensemble defining the area of Hoofddorp as a whole. Indeed, given the flatness of the polder landscape, pedestrians, cyclists, drivers, and even airline passengers descending to land at the nearby airport can view all three bridges at once from a certain distance. Within this programmatic framework, Calatrava developed a scheme for each of the three bridges using a combinatorial methodology generating different variations out of one motif: the cable-stayed steel pylon structure in the form of a spindle. The concept was derived from his graduate thesis, but here the changing combinations embody a special sense of movement, a musical, rhythmical quality given to each bridge in the landscape so that visitors circulating toward, across, or around them experience their movement from an inclined position to the vertical and back again.

Opposite: The Lute.

Following pages: The Harp.

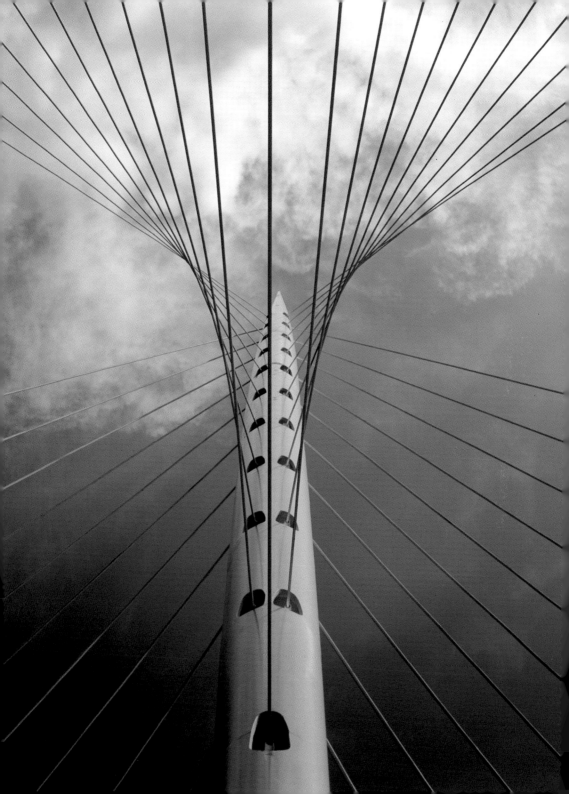

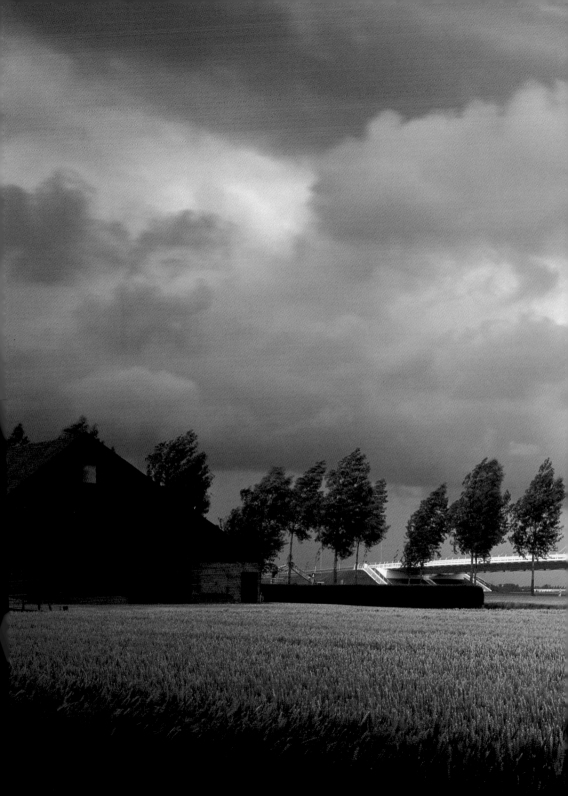

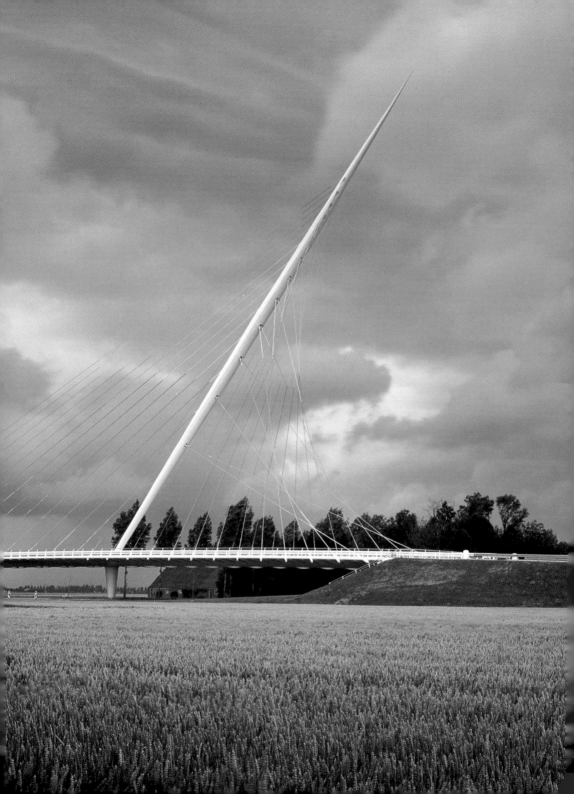

The first bridge in this sequence is the Harp, which features the largest pylon of the three bridges, with a height of 73 meters and a total length of 142.83 meters (with two spans of 86.94 and 55.89 meters). Forty-two piles had to be set in the unstable Dutch soil to distribute the concentrated loads under the pylon. The Harp marks the transition from the urban area of Nieuw-Vennep to the planned Twenty-first Century Park, a green area still in the design phase.

The Lyre is situated on the other side of this projected green area, providing access to the town of Hoofddorp. It consists of two connected spans, a lower bridge 19.6 meters long and a flyover set perpendicular to it with a total length of 148.8 meters composed of two spans 74.4 meters long whose cables are ingeniously linked to the pylon, which rises to a height of 58 meters. The usual lengthwise suspension has been substituted by a curious layout: the main stays form a plane perpendicular to that of the pylon. The Harp, on the contrary, follows the strategy of the Trinity Footbridge in Salford, where the pylon's inclination shares the same plane as the stays. The vertical curvature of the deck expresses faithfully and elegantly the forces at play.

In the scheme for the Lute, Calatrava reinterpreted the council's original plans, which called for the construction of a

Opposite: The Lute.

Following pages: View under the Lute.

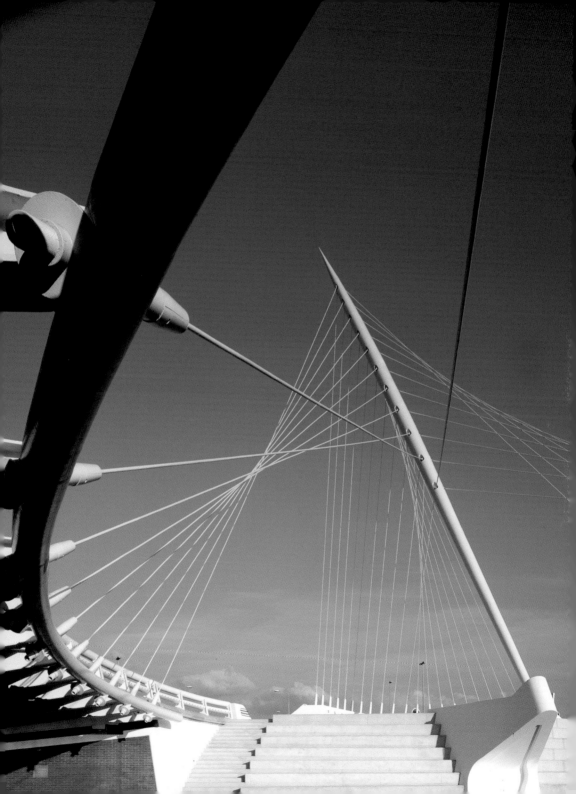

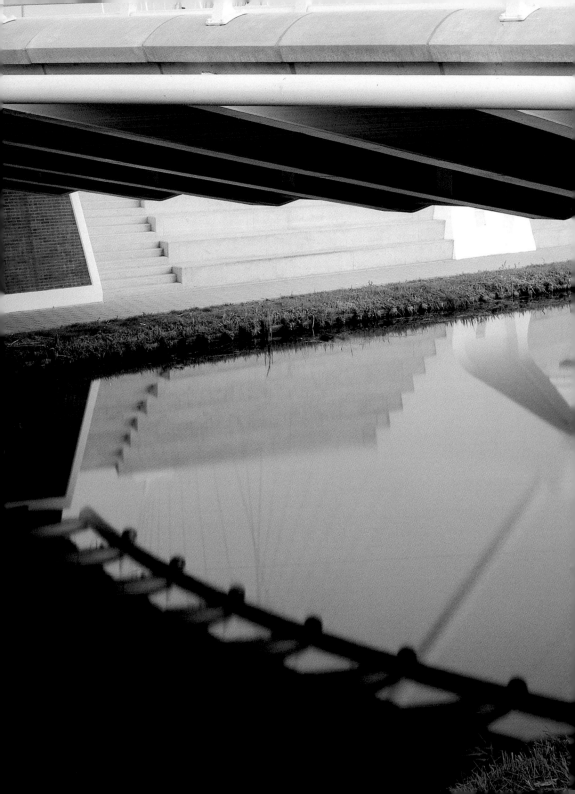

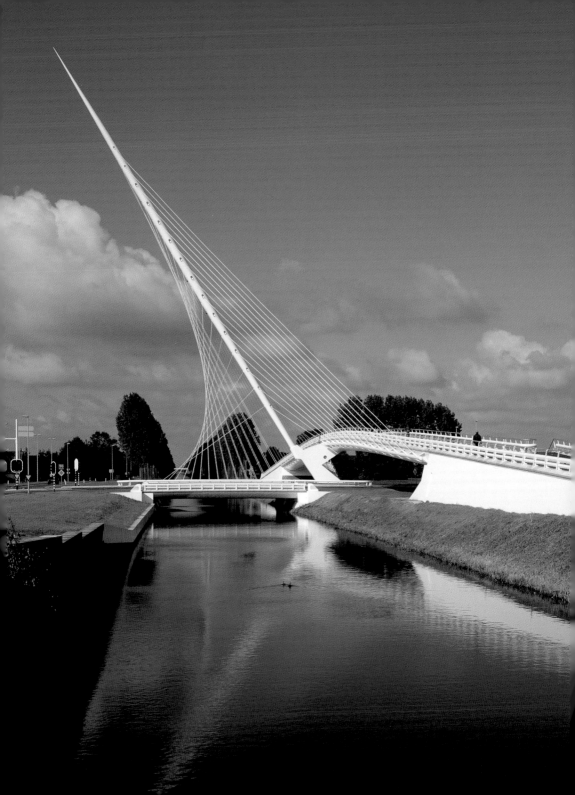

traffic roundabout at this location next to the Hoofdvaart canal. The scheme consists of two curved roadways, each 26.25 meters long, supported from a pylon that is 40 meters high. This solution, which in fact saves space, makes the tedious roundabout circuit an interesting experience. Also characteristic of this bridge is the special attention paid to the pedestrian. Of the three bridges, the Lute is closest to the urban zone and the residential area, and its formal playfulness makes it very attractive to local teenagers, who use it as a gathering place. The design of the roundabout includes a stepped terrace, descending from the deck to the water and accessible by a path parallel to the inland waterway. The arrangement of the cable stays defines an intimate, enclosed space in a conical configuration suggesting a natural protective niche. As in his previous projects, Calatrava gave special attention to all of the project's details, from the light fixtures to the guardrails provided for bicycle lanes. This made the projects sensitive to their surroundings on a scale different from the far vistas, closer to plants, shrubs, and flowers.

Opposite: The Lyre.

Above: View of Hoofdvaart bridges in the landscape.

4

Bridges and Landscapes of History

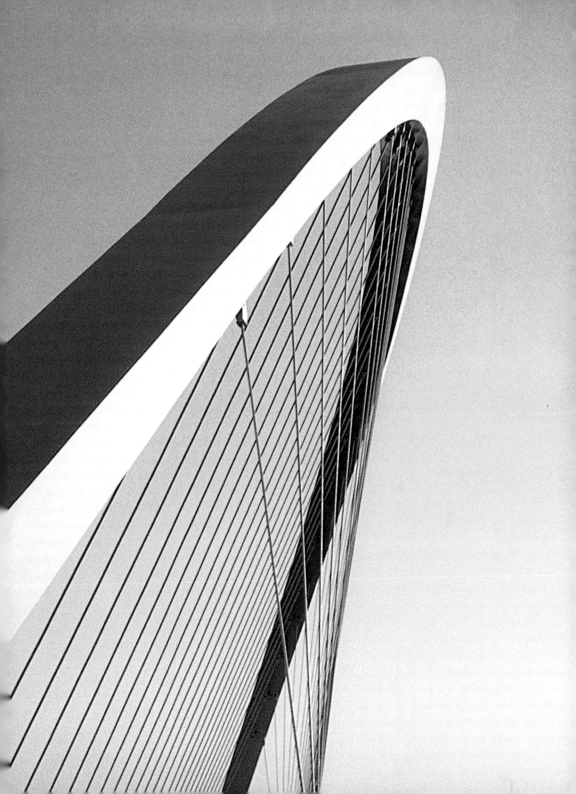

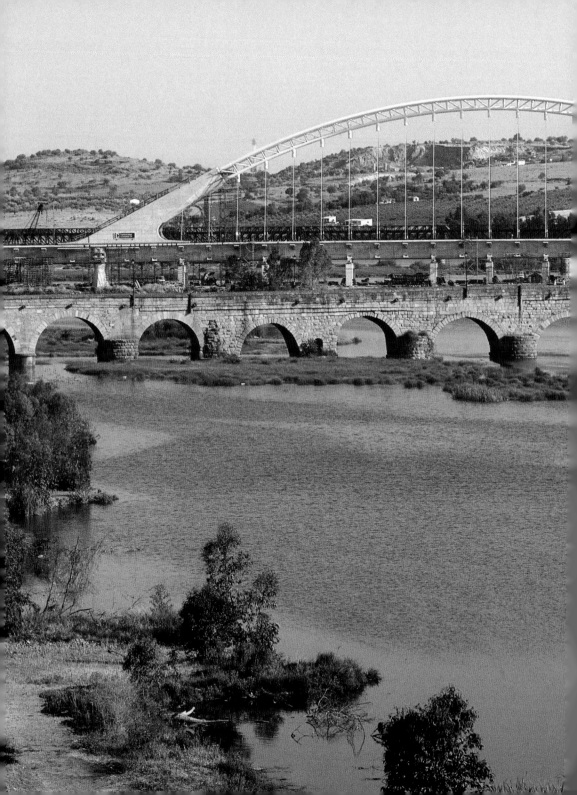

4 Bridges and Landscapes of History

Since the nineteenth century, the introduction of a large-scale structure into a historically rich environment has been viewed with disfavor, especially if it involved constructing a technologically ambitious infrastructure project. The technological intervention was interpreted as an act of warfare against memory and culture, to paraphrase Lewis Mumford once again. As with the introduction of industrial projects to a natural landscape, in the case of historical areas architects and urban designers have traditionally attempted a design strategy based on compromise: They resolved the conflict by denying its existence, typically hiding the new constructions behind the older facades, shoving them underground, turning the new artifacts into what Ruskin called in the "Lamp of Memory" "a false description of a thing destroyed," or seeking a "superinduced and accidental (picturesque) beauty . . . in ruin and . . . decay," an approach Calatrava rejects.

Despite the newness of the appearance of Calatrava's bridges, despite their cutting-edge technology, his approach does not negate memory. It refuses a passive, routinized, hypocritical, and amnesiac attitude toward the objects of the past. Even within a landscape loaded with history, his bridges have the power to make us responsibly aware of themselves as objects as well as of the events of our past.

Opposite: Lusitania Bridge, Mérida, Spain.
Following pages: Model of the Kiev Bridge.

Referring back to the Lusitania Bridge, we see that just as Calatrava differentiated the bridge from its natural setting, he also kept it conspicuously distinct from the two-thousand-year-old Roman bridge La Akazaba, only 600 meters downstream. Here the new structure gives the old one prominence and new life. Any mimetic approach would have achieved a diminished, even deleterious effect. Viewed from the side, the niche-like appearance of the bridge's prefabricated concrete elements repeats the rhythm of the Roman arches. Even more, conceptually rather than formally, the juxtaposition of the two structures — so similar in size and direction but so systematically different in scheme, with the Roman structure made out of a long sequence of arches supporting the deck from below, and the Lusitania consisting of one from which the deck is suspended — illustrates the evolution of the technical knowledge relied upon by both structures. In addition, the contrast reveals each structure through the other and celebrates the early achievement that established the foundations on which the new knowledge was constructed. Similarly, the scheme for the Kiev Bridge project is reflective rather than imitative. The curve implied by the two symmetrical, inclined, arched pylons of the new bridge structure refers to the form of the dome of the older building in the background, suggesting, as did the Lusitania Bridge, the evolution of built form and the spirit of community.

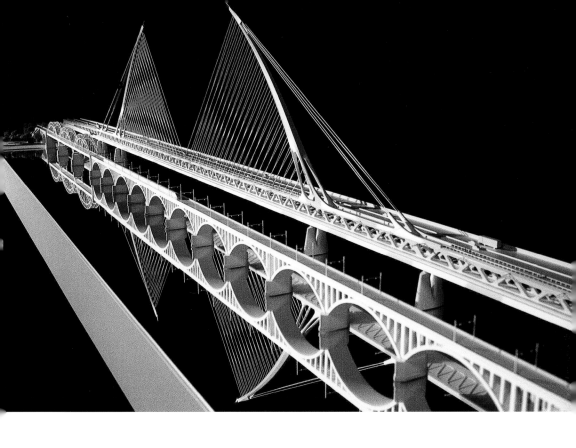

Opposite: Sketch of the Kiev Bridge with cathedral in the background.

Above: Model of the Kiev Bridge.

9 d'Octubre Bridge Valencia, Spain, 1986–88

Calatrava's first project for his hometown of Valencia was the 9 d'Octubre Bridge for vehicles and pedestrians. Commissioned in 1986, the bridge was built as an extension of Campanar Boulevard, providing a major vehicular link to the main Madrid road and relieving the areas of La Caldera and Olivereta from traffic congestion. Its deck crosses the former bed of the now-diverted Turia River and is conceived as a double viaduct, with the space between the two opposing viaduct structures determined by the layout of Avenida 9 d'Octubre. The scheme is distinguished by its horizontality and low silhouette in favor of a distinctive profile, which maintains the district's urban character. The only prominent gesture is an early iteration of Calatrava's sculpture *Pecking Bird*, standing at the end of

the deck in a manner reminiscent of the surging gilded figure of Pegasus at the end of the Pont Alexandre III in Paris, designed in 1900 by Cassien-Bernard and Cousin.

The total length of the bridge is 144 meters, and its height above the foundation is 4.9 meters. The predominantly concrete superstructure is supported along the length of its inner sides by concrete columns set 7.2 meters apart and along the length of its outer sides by interspersed steel spindles. The pedestrian decks are cantilevered from the main road decks by a series of trusses, which are scaled-down versions of the steel spindles supporting the road decks, thus elevating the pedestrian path from the main deck while also allowing a stream of natural light to reach the riverbed under-

Above: Section showing pedestrian and vehicular decks.

Opposite: Bridge beacon.

Following pages: Drawing of the in situ concrete embankment retaining wall.

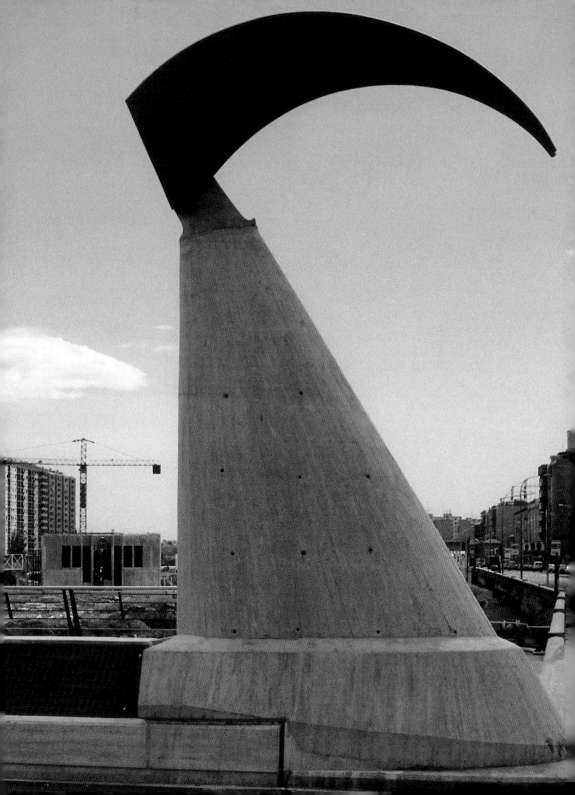

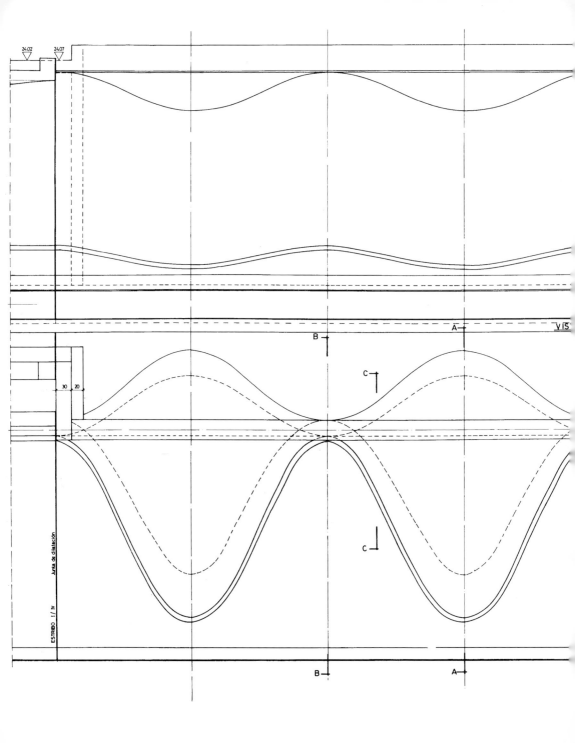

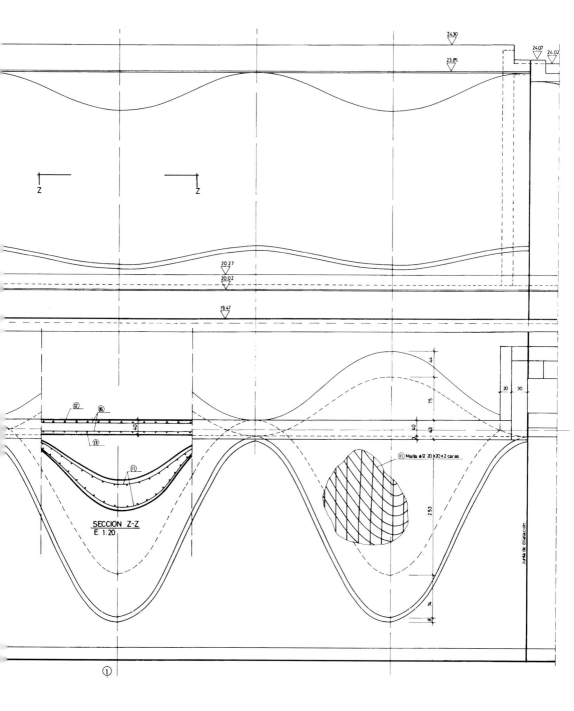

SECCION Z-Z
E 1:20

⑪ Malla ⌀12 20x20x2 caras

Junta de dilatación

neath, which has been converted into a park, softening the monumental appearance of the concrete soffit and revealing its delicate form. The 9 d'Octubre Bridge has many similarities to the Pont de l'Europe in Orléans, a project that took into consideration the environmental impact of the pylons on the riverbed and the delicate character of the Loire riverscape. The historical context of the site, with the dominating presence of the eighteenth-century Pont Royal, or Pont George V, was equally important in the conception of the scheme. The symmetrical piers, which are cut as modern bastions, create a new gateway for the city, acting in response to the same classical urban canon the Pont George V followed, with the two fortress towers that flank each end of that historic structure implying the spatial structure of the city and defining its historical entry. However, the inclination of the Calatrava arch, breaking with the older technology traditions of bridge arches, emphasizes the urban-civic continuity with the past.

Above: View toward beacon.

Opposite: Embankment retaining wall.

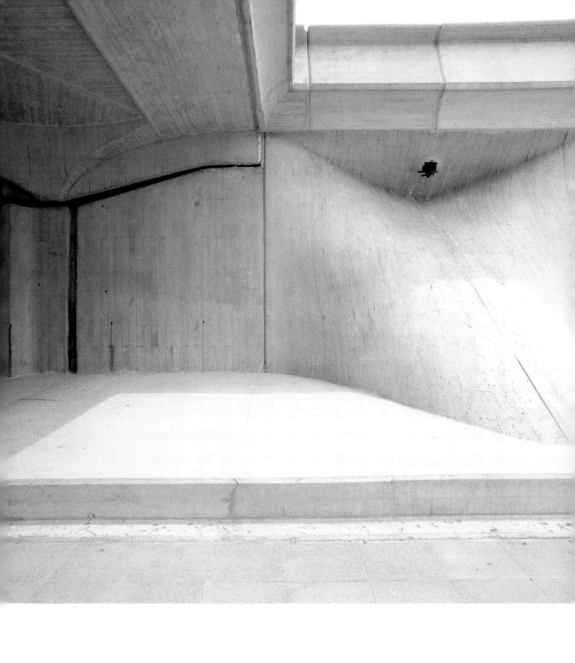

Oberbaum Bridge Berlin, Germany, 1991–96

The Oberbaum Bridge was designed in response to an invitation by the municipal authorities of Berlin to offer advice on the reconstruction of the bridge connecting Warschauer Strasse to the east with Skalitzer Strasse to the west, whose center span had been destroyed during World War II. The original bridge incorporated an overhead viaduct for an electric railway, opened in 1896. The center span was temporarily rebuilt after the war and was used for a subway line until 1961; since then it has been used solely for pedestrian traffic. The bridge was a key connector between the city's former East and West sectors, so its rebuilding was of extreme historical significance after the reunification of Germany.

Calatrava's original design proposed a center span on two levels: a lower level for motor vehicles and a tram line, and an upper level along the viaduct, on the upstream side of the structure, for the railway. The viaduct is a frame structure 22 meters long with a lower bracing arch. Ultimately the bridge's design was determined by politics. In addition, the

process was rather improper. In 1993, the German senate's planning authority decided to include a tramway in the bridge, which the city planners thought could not be accommodated by Calatrava's proposal. Without informing Calatrava, they proceeded to commission the firm of Wachendorf & König to build a concrete bridge for motor and tram traffic and commissioned Calatrava to design only the overhead railway viaduct.

The scheme resembles in part the New Bridge over the Vecchio, and though the motif fits within these two different contexts, it assumes a different meaning in each. Once more, Calatrava approached the problem of inserting a new object into a historical context by employing contrast and juxtaposition. Instead of masking the rupture of the war and the fracture of political conflict by emulating continuity between the two sides of the old bridge, the bridge preserves and makes manifest the memory of the trauma. In a deeper way, it suggests a nascent unity through the creation of the new.

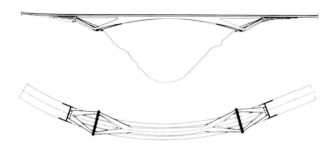

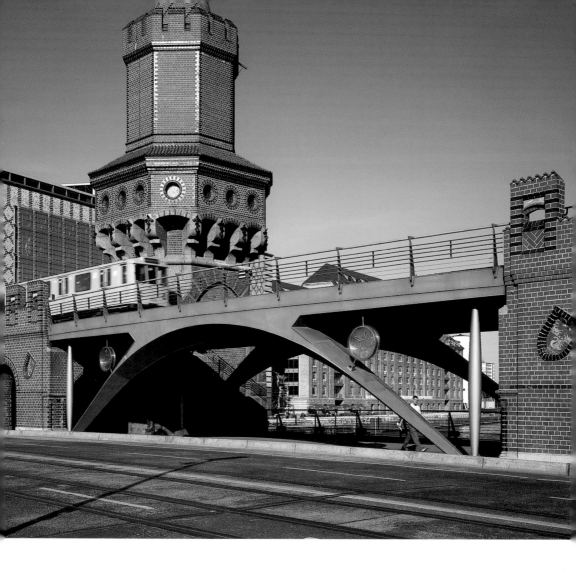

Opposite: Plan and elevation of the New Bridge
over the Vecchio.

Above: View of bridge with surrounding
urban context.

Kronprinzen Bridge Berlin, Germany, 1991–96

The original Kronprinzen Bridge, built over the Spree River in Berlin between 1877 and 1889, was based on Schinkel's Schloss Bridge. It was demolished in 1972 in a late attempt to prevent refugees from fleeing from the East to the West. Built on the same site and partially financed by the European Community, the new bridge over the Spree, like the Oberbaum Bridge, functions as a symbol of German reunification.

The primary structural system is a steel-stiffened arch reinforced by cross ribs, which support the metal road deck. These components are engaged at the top and bottom like the chords of a Vierendel truss, resulting in the reduction of both the weight and deflection of the span, permitting a shallower than normal arch. Although the oblique arches and the bridge's underside bear a passing resemblance to the space-frame and cantilevered appearance of the Wettstein

Bridge, in this case the entire structure is supported by cross girders. The cross section reveals the profile of these girders as arches spanning the shallow primary arches in a manner reminiscent of Maillart's three-hinge arched bridges. The abutments of these crosswise spans would be the main arches or the piers on which these arches rest. The road surface is 12.5 meters wide, with an elevated bicycle lane set one step higher than the road level, and a pedestrian path set a further two steps higher. The short lighting posts rise up to separate the pedestrian and vehicular surfaces. At either end of the bridge, a stair connection leads down to the river footpath. The longitudinal span adopts the traditional Spree bridge datum line, with its steel arches resting on piers and resembling a vessel's prow. These buttresses are of welded steel, with cast joints to receive the springing points.

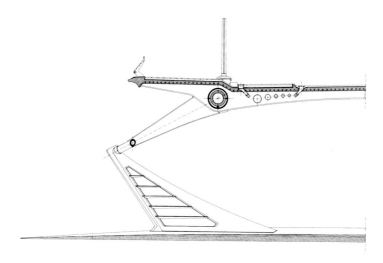

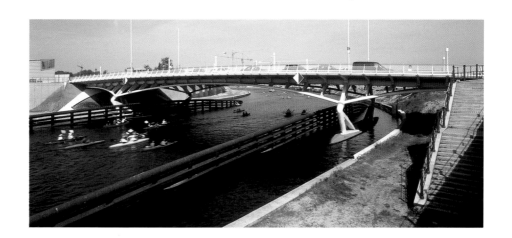

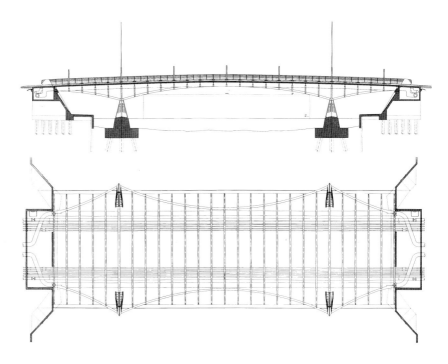

Opposite: Section of deck and pier.

Above, top: General view.

Above, bottom: Section and drawing of structure
under deck.

Solferino Footbridge Paris, France, 1992

In accessing the Louvre Museum through the lower entry of the Solferino Footbridge spanning the River Seine and linking it with the Musée d'Orsay, or when passing under it, one can view the lacelike pattern of the structure. Without doubt the light and translucent structure is engaged in conversation with the nearby Pont des Arts about the merits and folly of ornament. Like the Pont des Arts, the Solferino functions not only as a river crossing but also as a meeting place.

Calatrava developed the scheme as part of a competition organized to maximize access between the Louvre and the Musée d'Orsay. Calatrava's scheme offers a vaulted entrance to the Louvre with a connecting gangway on the Right Bank side. At the entrance, Calatrava placed a secure folding steel door, following the design principles of earlier folding structures he conceived as a formal analogy with the moving lids of an eye.

The design calls for the deck's central strip to be elevated slightly, providing a viewing platform with benches. This level of the bridge is inlaid with a marble-glass laminate. The lower level — the walkways running on either side of the viewing platform — are made of wood and placed longitudinally on the cross beams. At night, when the marble-glass platform is illuminated from below, its surface becomes a soft carpet of light through which the shadows of the bridge's graceful structure are visible. The delicate structural system — supported by abutments of cast steel built on a foundation of reinforced concrete — can also be seen from the edge of the bridge, reflected in the river's surface.

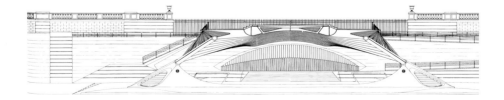

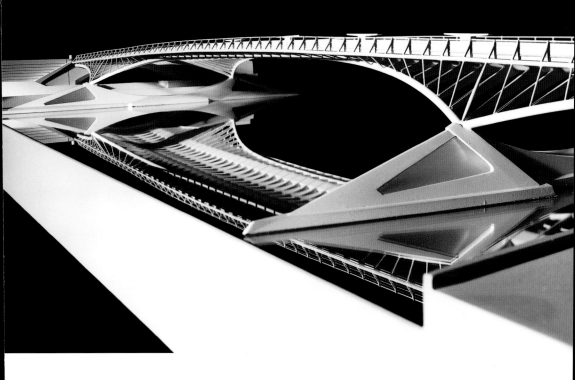

Opposite: Cross section.

Above: Model.

St. Paul's Footbridge London, England, 1994

As in the Solferino Footbridge, lightness and transparency are characteristics of the filigree-like design for the St. Paul's Footbridge, spanning the Thames, near St. Paul's Cathedral. The bridge was commissioned by *RA Magazine*, the quarterly publication of the Royal Academy of Arts, for an issue devoted to the Spanish Festival held in London in the spring of 1994.

The bridge has a more expressive profile than Solferino and a greater center-span rise in order to allow for sufficient clearance and to comply with shipping regulations. Like the Solferino, it appears to be in dialogue with its neighboring structure, in this case St. Paul's Cathedral, the great masterpiece of Sir Christopher Wren. However, here its seemingly decorative structure looks as if it is in opposition to the older structure: Wren's stern principle was that "of geometrical figures the square and the circle" —

which both dominate the Cathedral — "are most beautiful." In Calatrava's bridge they are absent. But on closer inspection, one is reminded of Christopher Wren's passage from the *Tracts on Architecture*:

> It seems very unaccountable, that the generality of our late architects dwell so much upon this ornamental, and so slightly pass over the geometrical, which is the most essential part of architecture. For instance, can an arch stand without butment sufficient? If the butment be more than enough, 'tis an idle expense of materials; if too little, it will fall; and so for any vaulting: and yet no author hath given a true and universal rule for this; nor hath considered all the various forms of arches.

In the St. Paul's Footbridge, Calatrava seems to have responded to this challenge.

Opposite: Photomontage.

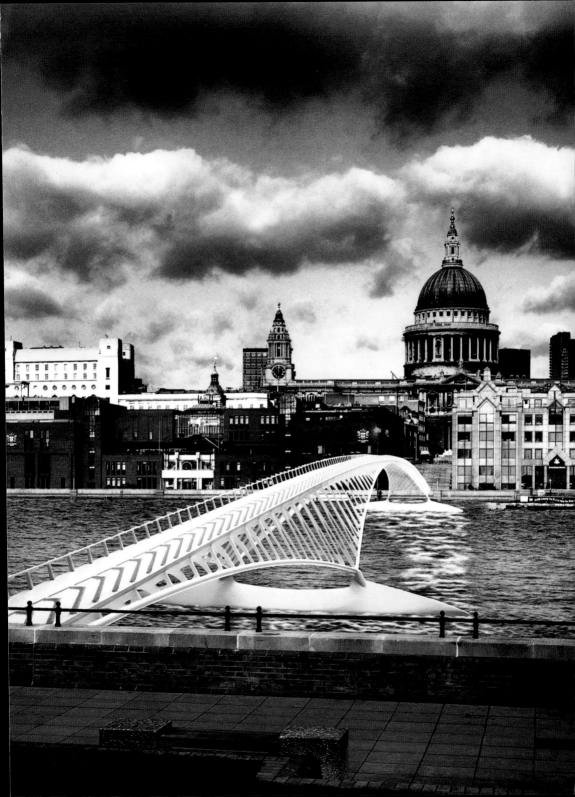

Quarto Ponte sul Canal Grande Venice, Italy, 1996–

In contrast to the expressive contour of the scheme for the St. Paul's Footbridge, the structure of the new pedestrian bridge by Santiago Calatrava on Venice's Grand Canal has a low and quiet profile. The Quarto Ponte sul Canal Grande, as the bridge is commonly called, is only the fourth to be built in the city since the sixteenth century, and so is clearly an architectural historical event of international importance. The first bridge on the Grand Canal was the Rialto Bridge, built between 1588 and 1591; the Accademia Bridge was built in 1932 (and rebuilt in 1984); and the Scalzi Bridge was built in 1934.

The location of the bridge is extremely important both functionally and symbolically, connecting as it does the railway station at the north end of the bridge with the Piazzale Roma on the south, offering to visitors their first impressions of Venice and providing them with a panoramic view of the Grand Canal. Care was taken to fuse the bridge with the quays on either side. The steps and ramps are designed to articulate the pedestrian's path on both sides of the canal, while the crescent-shaped abutments give free access to the quays. The areas at either end act as extensions of the bridge, creating new public spaces. On the south side, the design also provides a new passage between the Piazzale Roma and the mooring platforms for the Azienda Consorzio Trasporti Veneziano (ACTV) water transport.

The bridge is 94 meters long with a central span of 81 meters. The width varies, from 5.58 meters at either end to 9.38 meters at the midpoint. Similarly, the bridge rises from a height of 3.2 meters at the ends to 9.28 meters at the midpoint. The all-steel structural element consists of a central box composed of an arch with a radius of 180 meters, and two peripheral

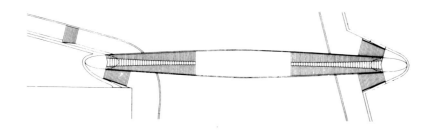

Above: Plan.

Opposite: Model.

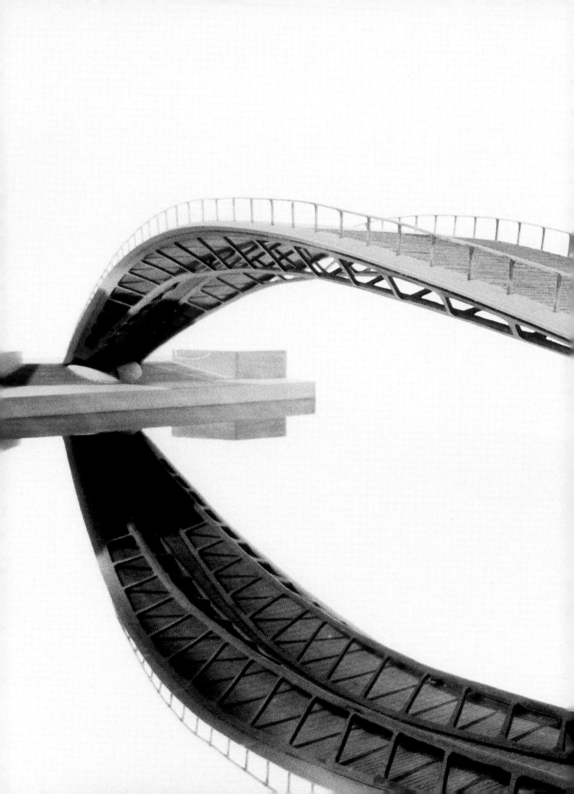

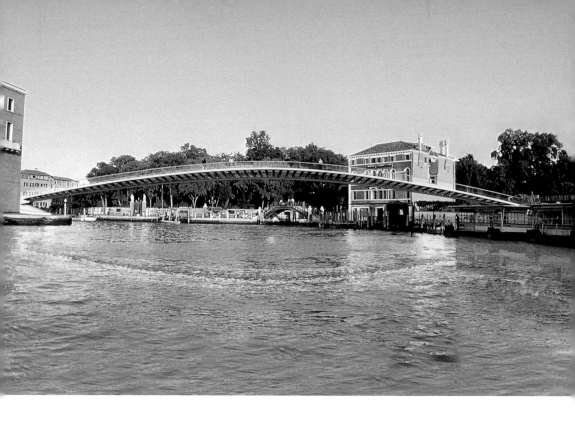

upper boxes and two lower arches. Joining the arches are girders made of steel tubes and plates forming closed section boxes.

The steps and deck of the bridge are made of alternating sections of tempered security glass and natural Istria stone, reflecting the design of the existing pavement. The abutments, made of reinforced concrete, are clad in the same stone. The parapet is entirely glass, with a glazed bronze handrail comprising its upper edge. At night, fluorescent bulbs set within the handrail illuminate the path, adding to the stage-set effect created by illumination from below the transparent deck. Spotlights set low on the walls illuminate the ground on either end of the bridge.

Like Le Corbusier, who was known during the 1950s for his flamboyant structures but who opted for an understated configuration for his Venice hospital project, Calatrava chose for this site a low-profile arch as if not wanting to disturb, to once more quote Ruskin, the "walls that have long been washed by the passing waves of humanity."

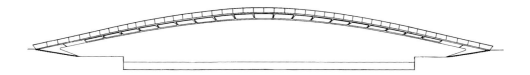

Opposite: Photomontage.

Above: Elevation.

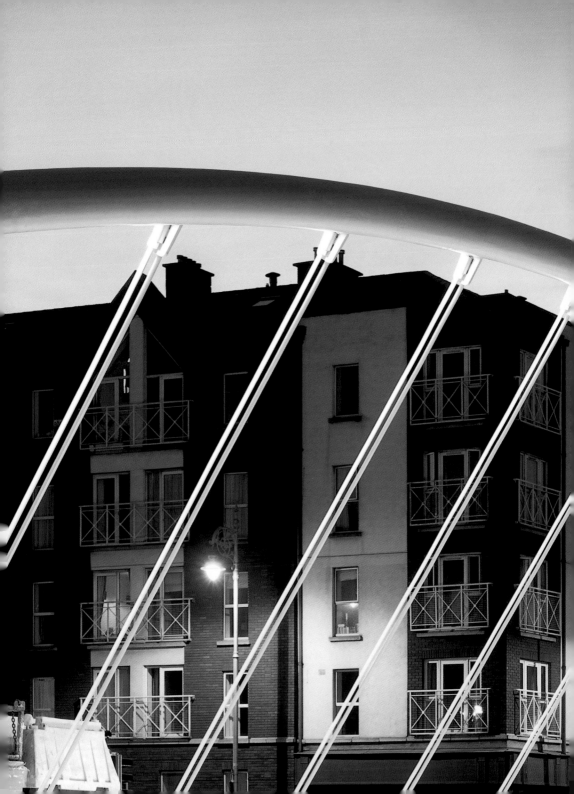

5 Bridges in Communities

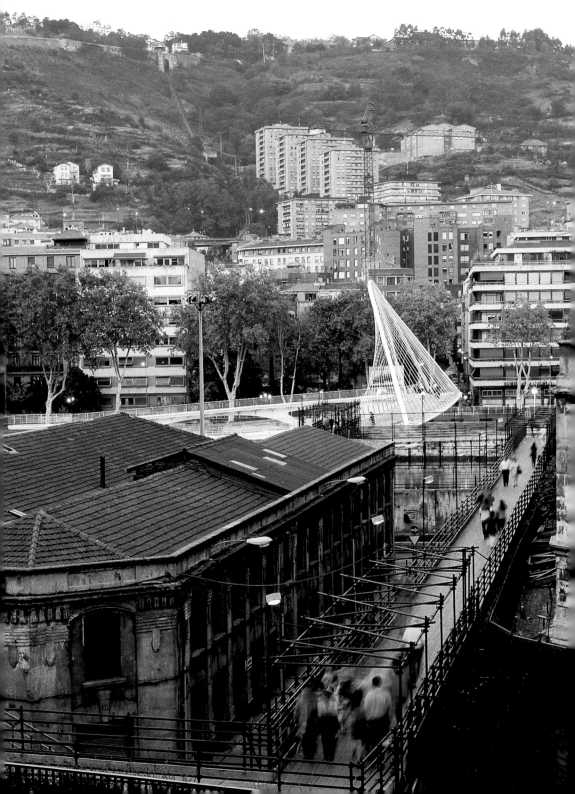

5 Bridges in Communities

Since the mid-1950s, the prevailing attitude among urban studies specialists and the general press has considered the introduction of new infrastructure projects to natural or historic sites to be sources of anomy and alienation. As with infrastructure projects inserted within natural or historical sites, the recommended panacea for such projects has been to keep a low profile. And again, Calatrava's approach departs radically from the conventional wisdom. Rather than structures reduced to the optimization of a single utility, they are multifunctional complexes dedicated to the provision of access for multiple systems and functions, enabling people to interact, physically but also symbolically, by offering dedicated ways, for instance, to approach the deck of a bridge, climb onto it, converse on it, enjoy the view, cross it, and descend from it. These are all social acts that foster and enhance human bonds.

A good number of Calatrava's bridges have been situated in socially challenging areas. Rather than being placed in sites of extreme natural beauty or conventional historical significance, they have confronted environments in some state of crisis, neighborhoods undergoing economic decline, forgotten communities, and obsolescent industrial sites. An exemplary case is the Trinity Footbridge, which was discussed in chapter 2, and which is flanked by two traditional stone-arch motor bridges in a district earmarked for commercial

Opposite: Campo Volantin Footbridge,
Bilbao, Spain.

redevelopment. Similarly, the Oudry-Mesly Footbridge was, as we have already seen, located in an alienating, late-modern no-man's-land. And both La Devesa Bridge in Ripoll and the Puerto Bridge in Ondarroa, each an example of a suspended bridge with an asymmetrical cross section, have a therapeutic effect, offering pedestrians new opportunities to restore human interaction and offering the town new conditions to revive its sense of community. Connecting the fragmented activities of an untidy area was the driving factor in the design of the Petah-Tikva Bridge, not far from Tel-Aviv, which integrated the scattered residential, commercial, health, and transportation facilities. The Katehaki Pedestrian Bridge in Athens, built for the 2004 Olympic Games, did not face the Acropolis or the Aegean but was placed in an almost unremarkable location overburdened by anarchic traffic and even more disordered construction. In all these cases, even if the area was loaded with historical significance, the scheme never turned the bridge into what Ruskin called, in the "Lamp of Memory," "a false description of a thing destroyed." Calatrava approached the bridge and its constituent components as agents immersed in a dynamic situation, enabling and inviting interaction.

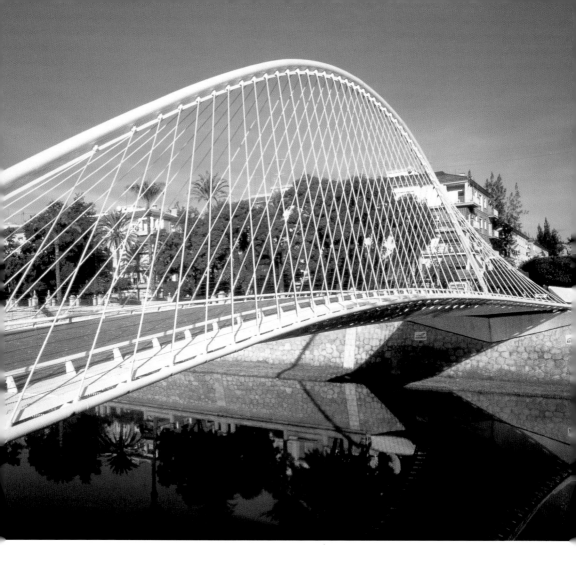

Manrique Footbridge, Murcia, Spain.

Campo Volantin Footbridge Bilbao, Spain, 1990–97

The Campo Volantin Footbridge is an essential part of a more general plan to redevelop the warehouses of an area that was rarely used. The intelligence, vitality, and originality of the bridge's carved configuration challenged the ordinariness and slow decline of the urban setting, bringing a message of hope and an invitation to imagine better conditions. An inclined, 14.6-meter-deep arch consisting of a pipe with a 457-millimeter diameter and a 50-millimeter thickness, opposes the 75-meter boardwalk curve it supports. The sweeping parabolic form of the arch rests precariously on the extended triangular armatures of the 2-meter-wide access ramps. Floating 8.5 meters over Bilbao's Nervión River, with a width between 6.5 and 7.5 meters, the board's flooring consists of glass plates of 28 by 180 centimeters. Composed of forty-one steel ribs with variable sections, double-T shaped and 10 millimeters thick, a 70-centimeter-wide galvanized steel grid along the outside of the glass flooring supports the stainless steel profiles.

The footbridge is in fact the second bridge design commissioned to be built at this particular point over the Nervión. The first project, the Uribitarte Footbridge, was designed in 1990 as a steel, inclined tied-arch bridge and box girder, following the principle of the Gentil Bridge, with a precast concrete deck. As with the Gentil Bridge, the suspension cables of a traditional arch system have

Above: Sections of deck and structure.

Opposite: View of structure beneath deck.

Following pages: Night view.

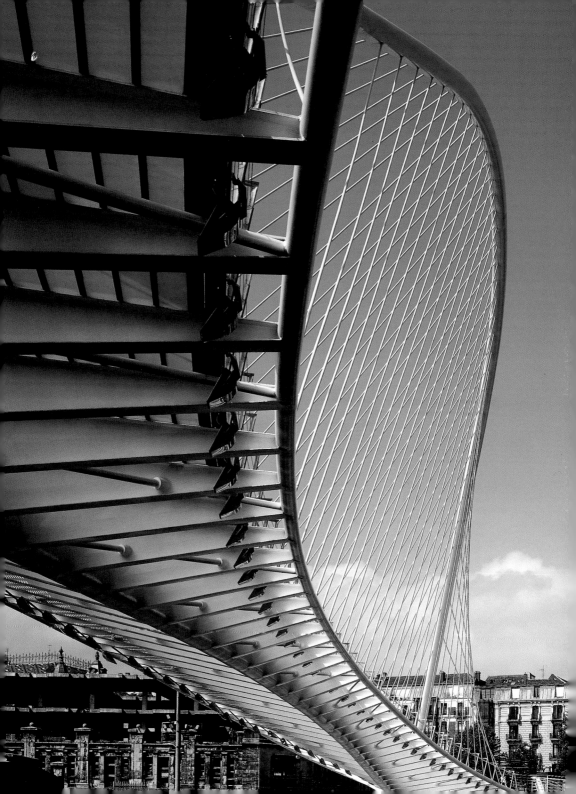

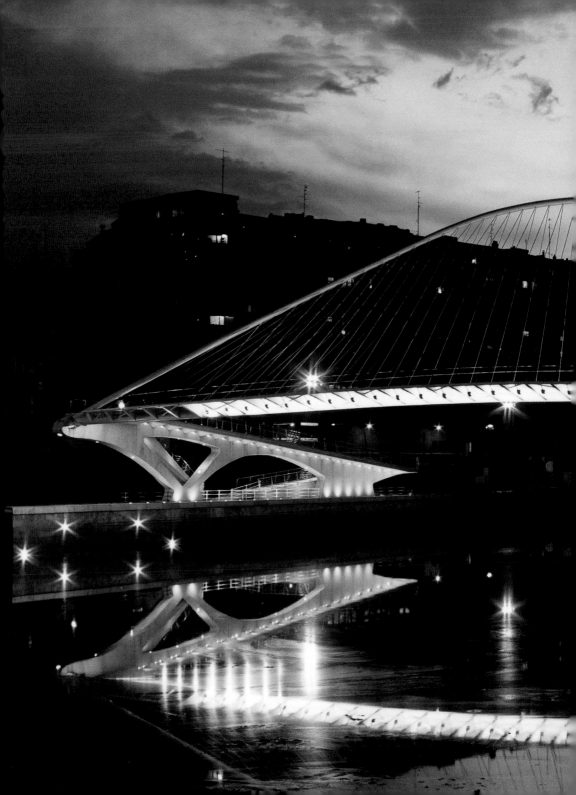

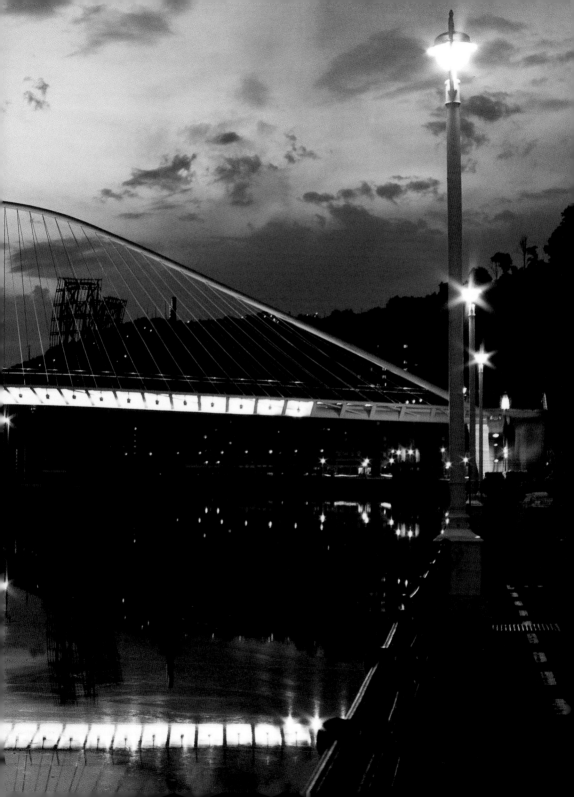

evolved into blades, suspended and pivoted from joints along the arch, with the arch appearing to lean almost too far, like a pendulum held captive, unable to return to its natural point of equilibrium. The Campo Volantin Bridge is also an inclined tied arch holding a curved deck. The suspension system has been altered, though, and instead of the rigid blades two sets of cables flank the pedestrian deck. As with the Alamillo Bridge in Seville, lighting plays an important role in the urban context of this project: Lighting sources are located between the steel ribs, illuminating the slab from underneath and in the handrails, stairs, and ramps; at night the bridge appears like a light sculpture, encouraging even more activity.

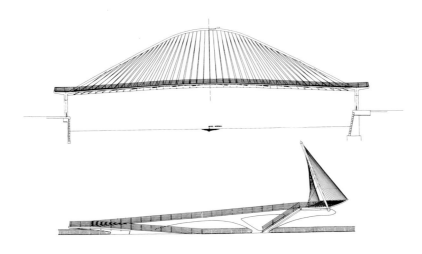

Above: Elevations.

Opposite: View of deck.

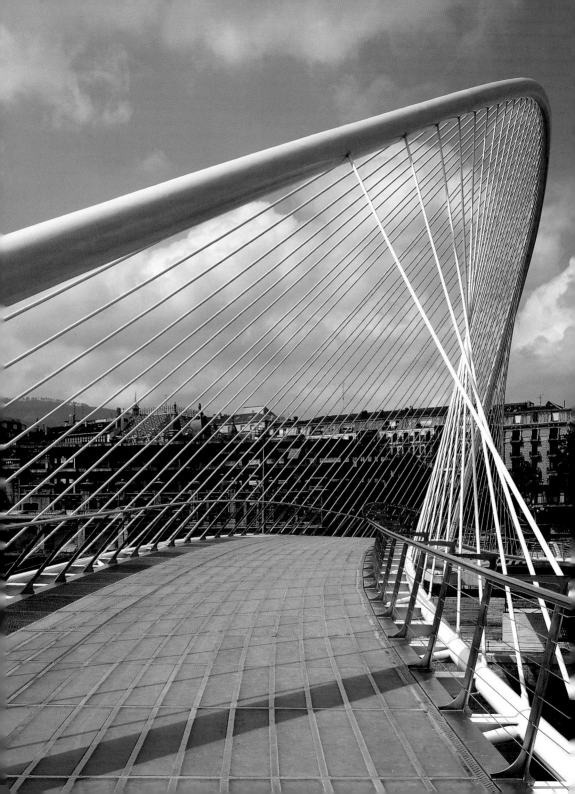

Alameda Bridge Valencia, Spain, 1991–95

In 1991 Calatrava was commissioned through a competition to design the Alameda Bridge, over the Turia River at Calle del Justicia and Calle de Alameda, in Valencia. A distinctive aspect of the project is that it includes a subway station placed immediately below the bridge, forming a single complex combining an infrastructure project and public space dedicated to making communication between people easier at local, urban, and peripheral scales.

Throughout history, Valencia has been identified with the Turia River, which provided a natural defense for the city. But due to its frequent catastrophic flooding (despite the impressive walls built by the Masonic guild), its path was permanently diverted in 1957, with the resulting tract of land transformed into a linear park bisecting the city.

The Alameda station, running on the same longitudinal axis of the river, was to become an important subway node, with two lines meeting under the Turia riverbed. Calatrava's original proposal for the site linked the station with the university campus and the old town. In his later proposal, however, the entire station was covered, creating an open outdoor space over its ceiling. People walking across through the riverbed become aware of the subway through the paved translucent-glass surface and a series of protruding, angled skylights. Ramps and stairs on either side of the embankment lead to the subway. Its platforms are accessed through elevators contained in the buttresses of the bridge or through escalators and stairs that are accessed through mechanical folding doors that are set flush with the paving when they are closed, sealing the station.

Again light is very important for the scheme, underlining its character as a public gathering place. At night, light filters up from the subway level through the

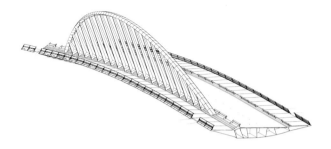

Above: Drawing showing structure of bridge.

Opposite: View with urban context in background.

Following pages: Night view.

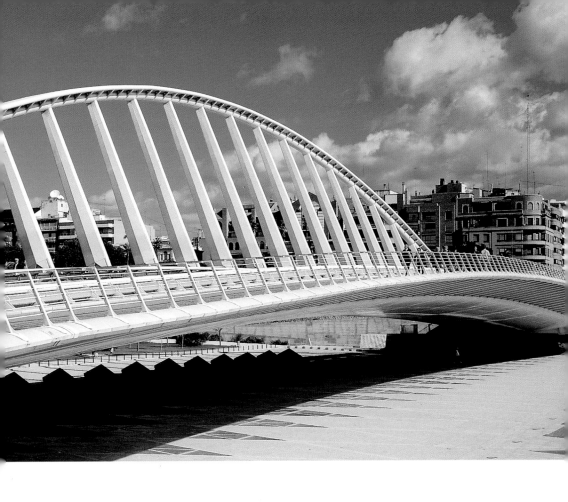

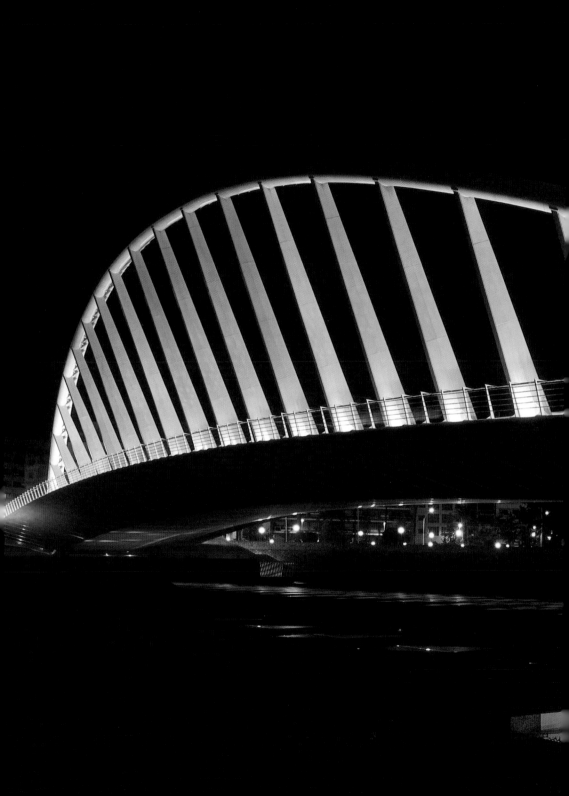

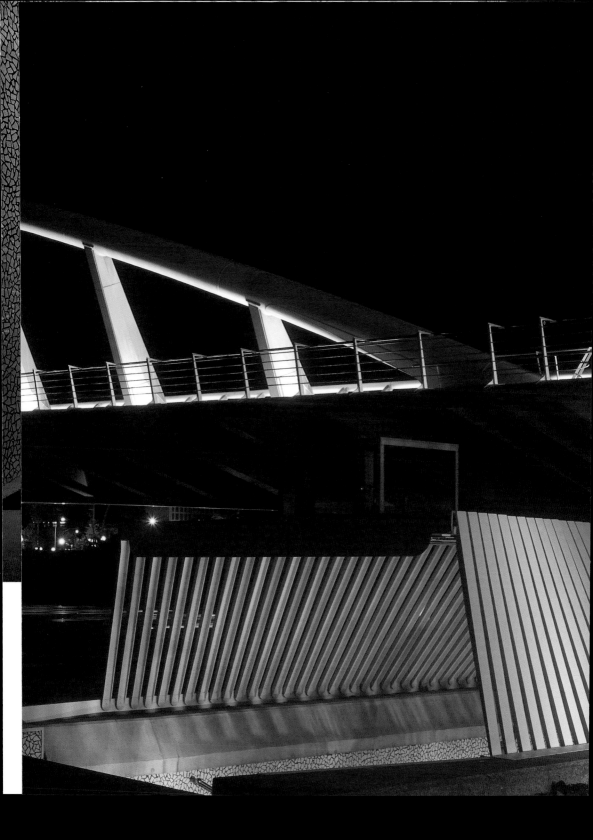

Hospital Bridges Murcia, Spain, 1993–1999

Using the leaning arch structure scheme, Calatrava designed two bridges for the city of Murcia, in the southeast of Spain, to cross the Segura River: the Manrique Footbridge and, 300 meters upstream, the expansion of an existing bridge to create what has become known collectively as the Hospital Bridges. Calatrava's challenge was to establish a pedestrian realm with implicit urban connections and direction within a rather amorphous existing site context. The project brief for the bridge describes it as doubling the width of the existing bridge in order to relieve the traffic bottleneck and adding two new roadways, built on either side of the existing structure. Each of the new roadways has a slanting steel arch that rests on white concrete piers situated at either end of the bridge and rises to a maximum height of 11.2 meters at its central point. Each arch is designed as a tubular structure of steel plates connected by means of an additional system of taut cables to the side of the box girder. The decks are 53.5 meters long and measure 12.2 meters in total width. The symmetrical placement of the new roadways provides a striking visual framework for the old bridge while making the structure as a whole an attractive public space.

Above: View with urban context in background.

Opposite: Detail of leaning arch structure.

Following pages: Evening view.